To all the creative people who struggle to bring their dreams to reality.
—Vicente Wolf

"Memory
I had smiled. Nothing more. But brightness was in me, and in the
depths of my silence. He was following me. Like my shadow, irreproachable and light…"

A poem by fifteen-year-old Frida published in the November 30, 1922 issue

of literary journal El universal illustrado

Frida Kahlo: Photographs of Myself and Others

from the VICENTE WOLF COLLECTION

POINTED LEAF PRESS, LLC.

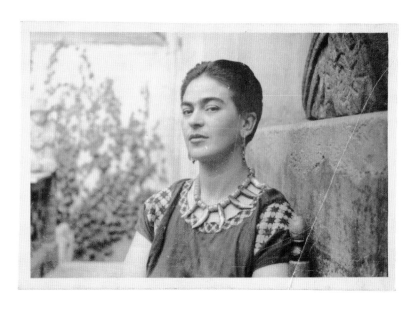

"I have to give you bad news: I cut my hair, and look just like a ferry [fairy]."

Frida, in a letter to Nickolas Muray, New York, February 6, 1940. Because she knew how much Diego loved her long hair, Frida cut it short in response to their divorce.

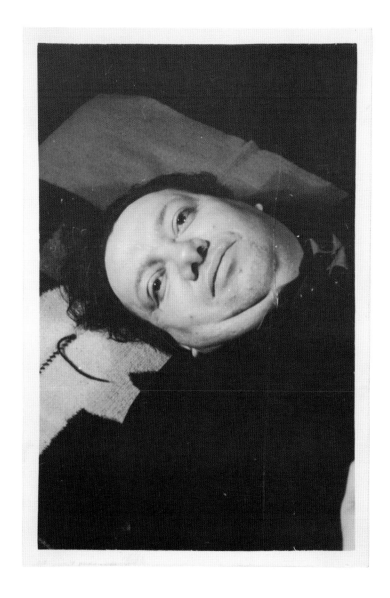

Diego. Beginning.
Diego. Builder.
Diego. My child.
Diego. My darling.
Diego. Painter.
Diego. My lover.
Diego. *My husband.*
Diego. My friend.
Diego. My mother.
Diego. My father.
Diego. My son.
Diego. *Me.*
Diego. Universe.
 Diversity in unity.
 Why do I call him *my Diego*?
 He never was nor will he ever be mine.
 He belongs to himself.

Frida, in her diary, late 1940s

My Frida I've been collecting vintage photographs for the last thirty-seven years, and as a serious collector, I am always trying to upgrade my collection. Around six years ago, I got a telephone call from Anne Horton, who was at one time the director of the photography department at Sotheby's in New York and knew me from the auction rooms. She asked if I had any clients who might be interested in a collection of about four hundred and fifty personal photographs that had once belonged to the iconic Mexican artist Frida Kahlo. Anne showed me photocopies of the photographs and asked if I could come up with a list of clients who might want to own them. Because of the high price she mentioned, it never occurred to me that I could be the buyer. But I did know a collector who might be interested. When I showed him the photocopies, he was very intrigued. I told him that instead of a finder's fee, I wanted to pick three photographs from the collection. He refused, saying he would pay me a fee but nothing else.

Nevertheless, to satisfy my curiosity and for the sheer pleasure of seeing the photographs in person, I accompanied Anne to the gallery that belonged to Mary-Anne Martin, the famous Latin American dealer who was selling them. Anne and I went through the photographs one by one. After looking at each photograph for the first time, I suggested that Anne price each one individually, and the total sum came to more than the asking price for the whole collection. I realized then that anyone who bought the collection wouldn't be able to sell any of the photographs individually, because the strength of this collection is in keeping it together.

That was the moment I thought, "How often does anyone get this chance?" The provenance was perfect. The personal items once belonging to great artists—whether Picasso, Braque, or Man Ray—rarely show up on the market, as most of the rare artifacts that were part of their daily lives are already in museum collections. And how many artists were left like Kahlo, where an assemblage of their intimate diaries, photographs, and letters were still out in the world? I saw it as an amazing opportunity. If I had not been talking to Anne about an article on photography, perhaps the possibility would never have come my way. And although it was to be the largest sum of money I would spend at one time in my life, I felt no apprehension about it.

A meeting was set up with the owner of the collection, a very eccentric individual who, over time, had entwined herself with parts of the collection as if Frida had actually been her intimate friend. The woman was very protective of the material and wanted to know who the purchaser would be. She would never let the pictures out of her sight: When someone in New York wanted to see the photographs, she would accompany them to the meeting. She wanted to know what I would be using the collection for and whether I would be keeping the photographs together. I answered that I was a collector of photographs and not a dealer and that I would not break up the collection.

We set a date for the transfer; I mortgaged my house. I felt peculiar riding the subway with the certified check in my pocket, on my way to meet the woman in the vault of a bank in downtown Manhattan.

After I gave her the check, she handed it to her lawyer, who made sure it was real. She gave me the wheelie suitcase that contained the photographs, which I dragged on the subway back to my office. As I rode the train I wondered, "If only the people holding on to the poles around me knew what was in this ugly bag!"

Until the Walker Art Center, in Minneapolis, asked me to get involved with its Frida Kahlo exhibition, the collection just sat in my home. I decided to try to have it published. But as I showed the collection around, my breath stopped when people sometimes asked me, "Does anyone really know who she is?" or "Isn't it all about her paintings?"

I remember going to a private viewing many years ago of jewelry that had belonged to the Duchess of Windsor. Only about forty people attended. The pieces were out on display. When I saw one of the bracelets she wore, I thought I could almost smell the person. That sensation was similar to the way I felt about Frida's photographs and the reason I was so captivated by them. Her persona is more palpable through these images than through her paintings.

I was amazed at how meticulously Frida crafted her own image, almost as though she were a third party to what she was looking at. In one of the photographs, she increased her brow; in another, she changed her expression or erased a vein in her neck. She was always editing, refining her image, analyzing herself. What she wanted was for the images to stand in for her totally individualistic look. The fact that she became such an iconic image was not by chance.

The relationship between Frida and Diego Rivera was the other element that fascinated me about the photographs. I looked at all the pictures of him with young girls. He was so unattractive, but somehow women were captivated by him. So was Frida. She knew all Diego's admirers. Photographs of them were in her own album—there she was among his other lovers.

Frida's paintings were created for the world: for a public audience and, hopefully, to be sold. But this collection shows a very personal view and exposes her vulnerable side—lying in bed, all bandaged up after a spinal surgery, or sitting in a wheelchair. She wrote things on the backs of photographs. She kissed them. The notes she wrote to Diego—these were the very private things she was not looking to share.

Included in the collection are some images by master photographers. Manuel Álvarez Bravo. Tina Modotti's portrait of Diego. Some are by Frida's father, who was a well-known photographer in Mexico City.

For me, these photographs are the greatest. They show the woman and the man she loved. They go beyond just pretty pictures: These are the images that truly bring Frida and Diego to life.—VICENTE WOLF, January 2010, New York

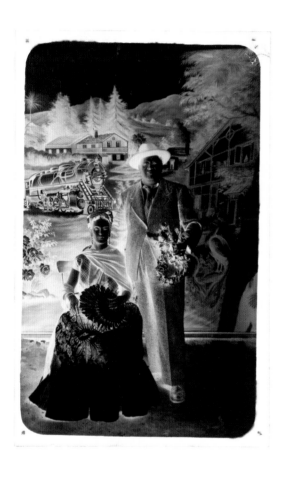

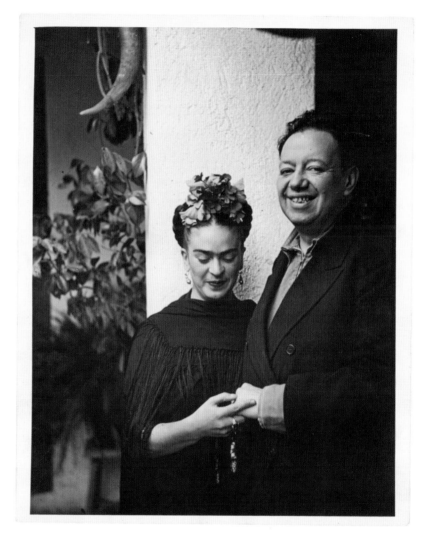

Above left: Frida and Diego, posed like a traditional Mexican couple at a fair in the early 1940s.

Above right: Nickolas Muray photographed Diego and Frida in Tizapán, Jalisco, in 1937, the year before Muray began an affair with her.

When their liaison ended in 1939, he would write in a letter to her: "Of the three of us there were only two of you. I always felt that. Your tears told me that when you heard his voice. The one of me is eternally grateful for the Happiness that the half of you so generously gave."

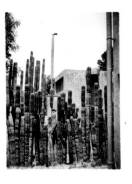

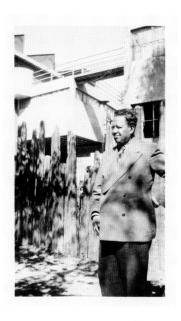

"*Like the cactuses of his birthplace, he grows strong and astonishing, even on sand or stone; he blossoms with the most vivid red, the most transparent white and solar yellow; clad in thorns, he keeps his tenderness within. He rises with surprising strength and, as no other plant, blossoms and bears fruit.*" Frida, "Portrait of Diego," the introduction to the catalog for Diego's retrospective in Mexico City, 1949

Far left and left: Diego was photographed at the San Angel property where he had two attached but separate studio-homes built for Frida and him. A fence of native cactus was planted around the entire property, and a distinctive, broad, outdoor circular stairway curled up the back of his studio.

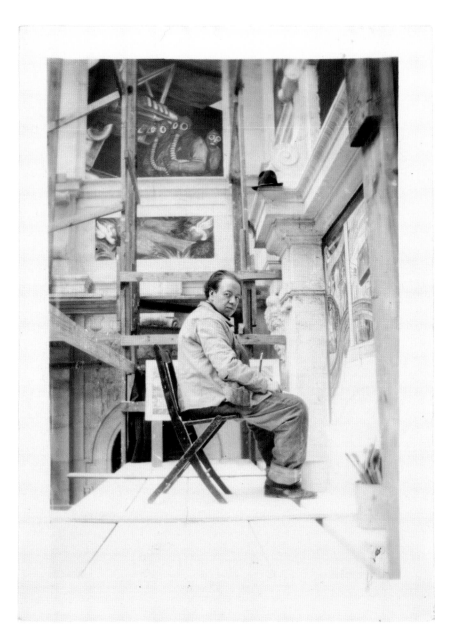

Diego worked on the Detroit Industry *mural at the Detroit Institute of Arts from 1932 to 1933.*
He spent several months researching factories across Michigan before beginning the work. He believed that modern
technology would be an artistic and political boon to the working man.

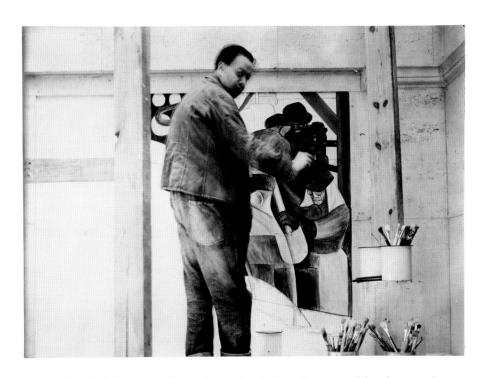

Left and above: A detail of the west wall portal was sketched on the verso of the photograph that showed Diego working on the north wall of the Detroit Industry *mural.*

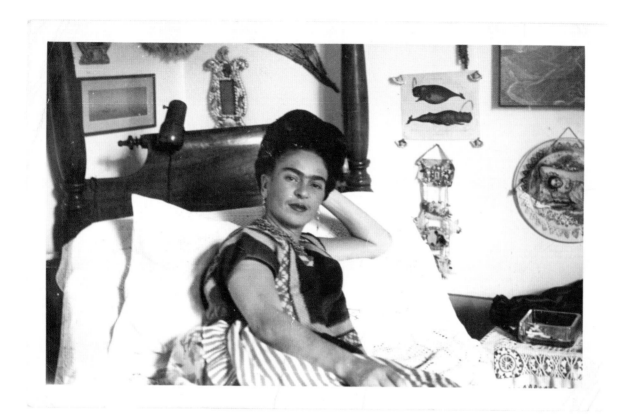

"I recommend her to you, not as her husband, but as an admirer of her work:
sour and tender, as hard as steel, and as delicate and refined as the wing of a butterfly,
adorable as a beautiful smile, and deep and cruel like the bitterness of life."

Diego described Frida in a note to Sam A. Lewiston, an American film critic.

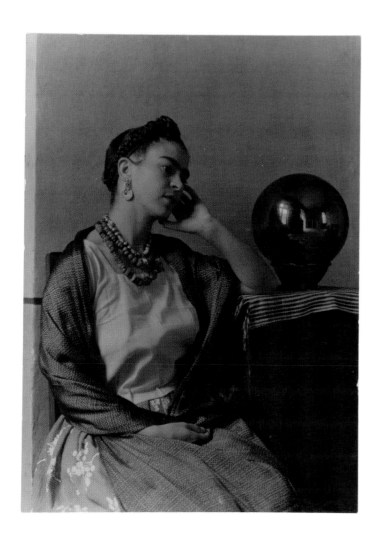

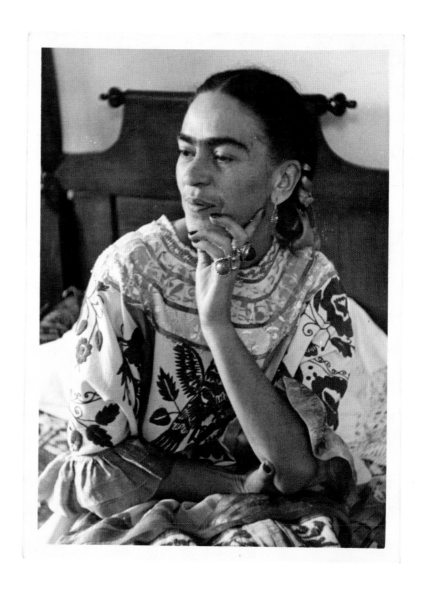

Left: Frida photographed by Manuel Álvarez Bravo in 1938 at Casa Azul.
The following year, his photographs and her paintings would
be shown together in the Paris exhibition "Mexique."

"He holds special adoration for the Indians, to whom is he linked by blood; he loves them intimately for their elegance, their beauty, and because they are the living flower of the cultural tradition of America." Frida, "Portrait of Diego," 1949

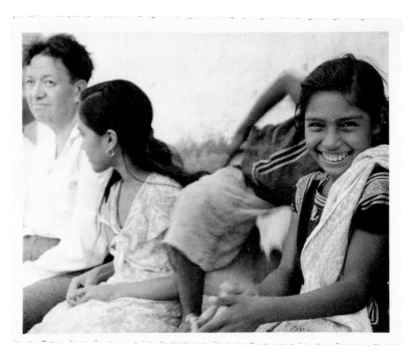

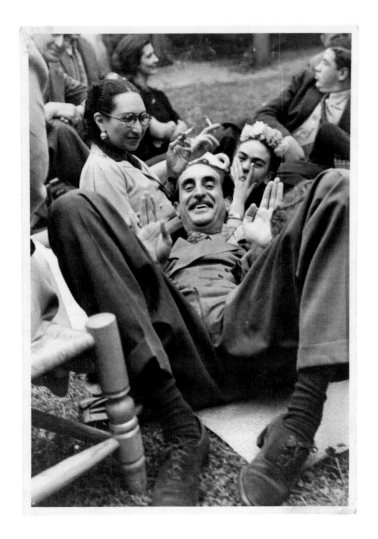

Left: Frida relaxes with friends including the Mexican painter and film director Adolfo Best Maugard, center, artist Malú Cabrera Block, on his left, and artist and illustrator Miguel Covarrubias, upper right.

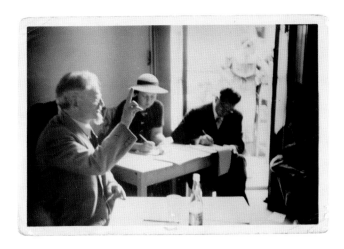

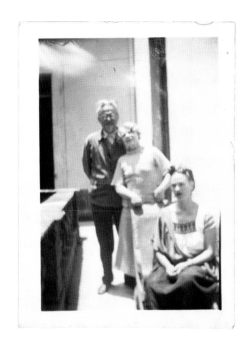

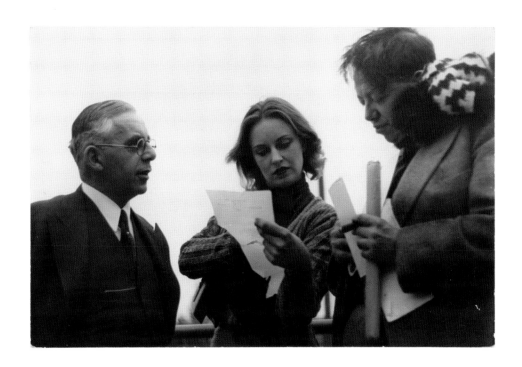

Above left: Leon Trotsky, left, testifies at the Dewey Commission hearings, at Casa Azul, April 1937. John Dewey and other members of the American Committee for the Defense of Leon Trotsky came to Mexico to "acquit" Trotsky after he was found guilty of treason in the Moscow Trials under Stalin. Above: Diego compares notes with Alfred Honigbaum, a California collector of Mexican art, and an unidentified woman. Left: Frida was photographed with Trotsky and his wife, Natalia, at Casa Azul, where the couple lived for two years after their arrival in Mexico in 1937.

Below: Lucienne Bloch, Diego's assistant, photographed him and Frida as he took a late-night break from painting
the murals for the New Workers School in New York City in 1933. Below right: Diego, center, with André Breton,
the French surrealist writer, left, and Leon Trotsky in 1938, when Breton and his wife, Jacqueline, visited Mexico.
The three men were very close at this time, traveling around the country together, discussing art and politics,
publishing political and artistic essays, and organizing exhibitions.

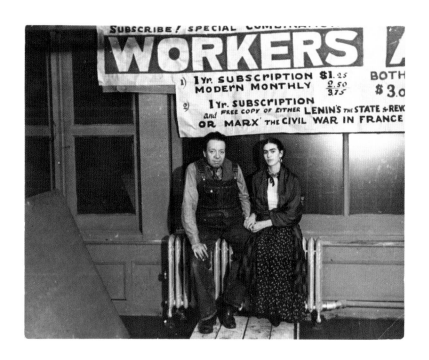

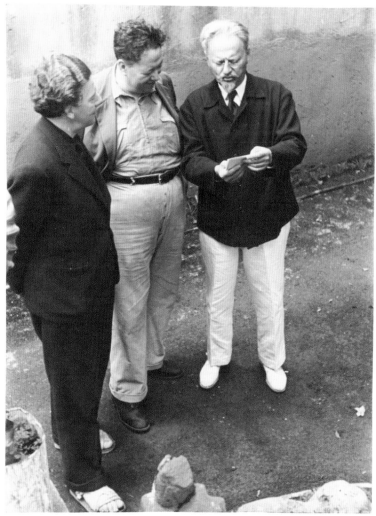

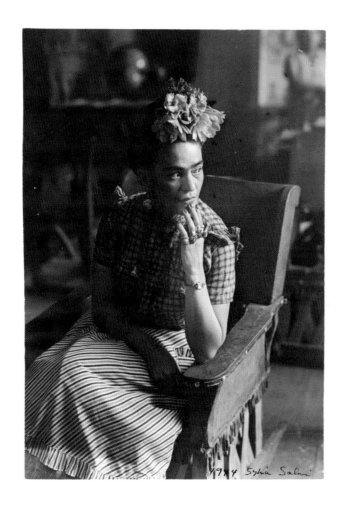

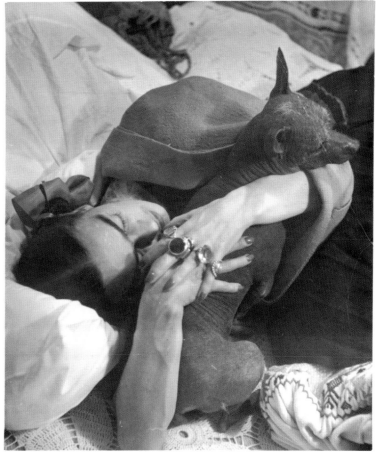

"*The only thing I want is for you to get better so you can come back soon to live with me and with Señor Xolotl,*" Frida wrote in a letter to Diego in 1947.

Above right: Even though there were always several Xoloitzcuintli dogs living at Casa Azul at any given time, Señor Xolotl was the favorite.

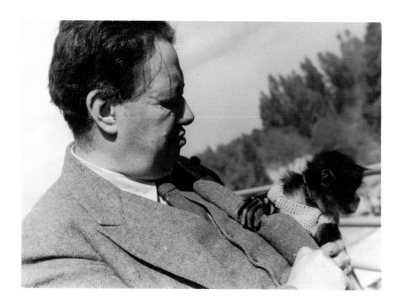

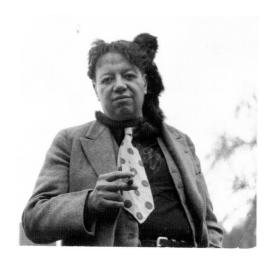

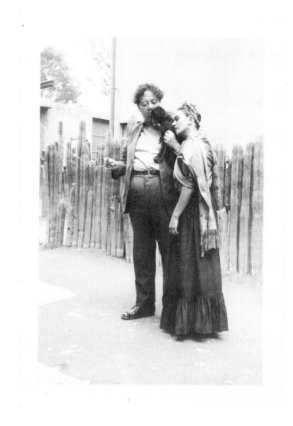

This page: Of the pet spider monkeys in residence at Casa Azul and San Angel,
the most loved was Fulang-Chang, whom Frida included in several of her self-portraits.
He often roamed free, pulling tricks at meals and on guests.

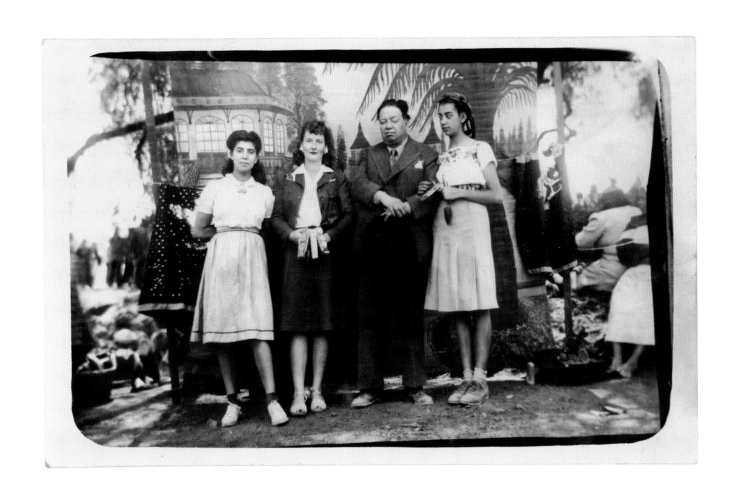

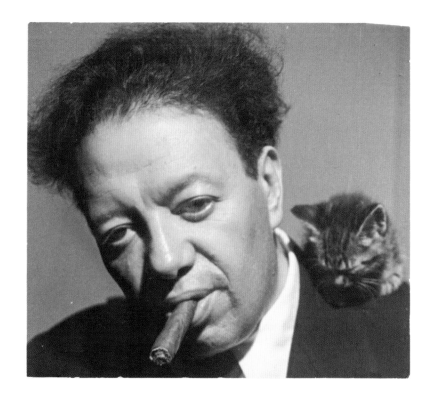

Diego portrayed circa 1929 by Tina Modotti, a fellow Communist who had come to Mexico with the photographer Edward Weston in 1923. It was through her that Frida and Diego reconnected before they married.

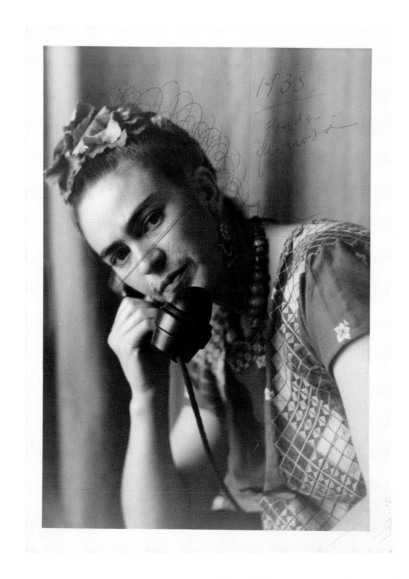

On a portrait by Nickolas Muray, Frida wrote, "1938 Frida furiosa."

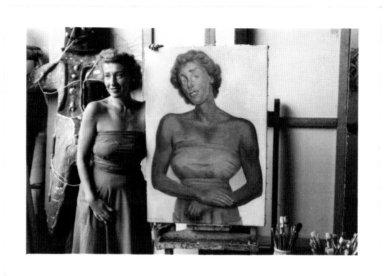

Art collector Theresa Feibelman poses in Diego's San Angel studio.

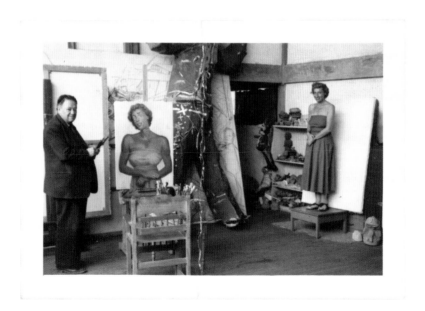

"To Diego, painting is everything.
He prefers his work to anything else in the world.
It is his vocation and his vacation in one." *Frida, 1949*

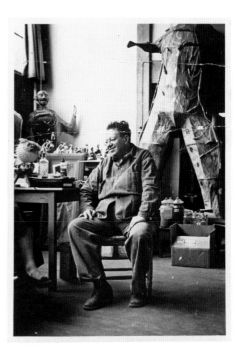

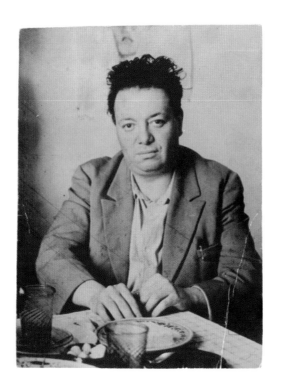

"As always, when I am far from you I carry your world and your life deep within me, and that is what I can't recover from. Don't be sad—paint and live— I adore you with all my life." *Frida, in a letter to Diego, 1948*

Above: Diego around 1929, the year he married Frida. He is forty-two years old; she claimed to be nineteen but actually turned twenty-two that year. She planted two pink lipstick kisses on the back of the photograph.

Frida posed for her father, Guillermo Kahlo, a photographer, the month after her mother died.

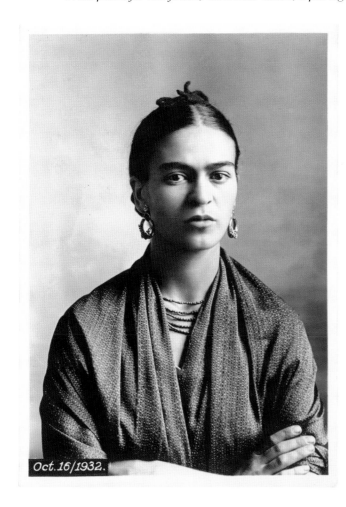

Oct. 16/1932.

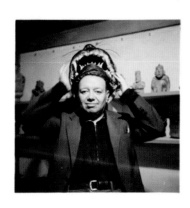

"I can't live without my darling little child."

Frida, in a letter to Diego, September 10, 1932

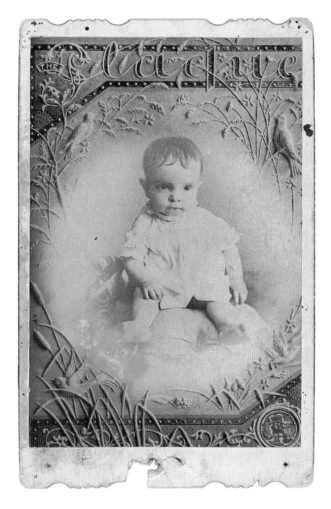

The well-worn baby picture is of Diego María de la Conceptión Juan Nepomuceno
Estanislao de la Rivera y Barrientos Acosta y Rodríguez when he was a year old, in 1887.
It could also be of Jose Carlos, Diego's twin brother, who died very young.

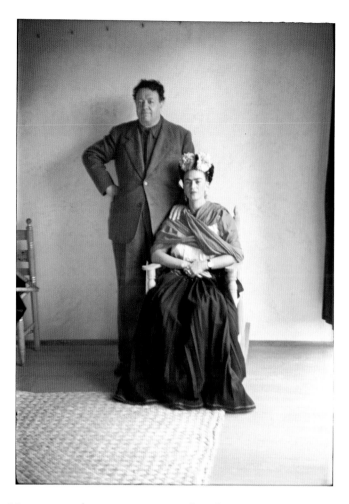

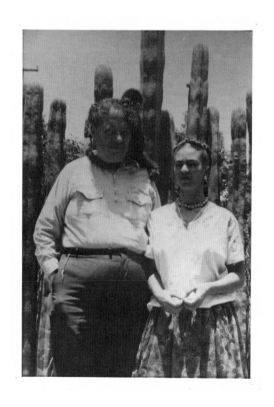

Above right: Nickolas Muray, an early experimenter in color photography for the magazine trade in New York, took this 1941 portrait of Diego and Frida at San Angel in the first year of their second marriage. Frida and Muray remained friends after their romance ended in 1939.

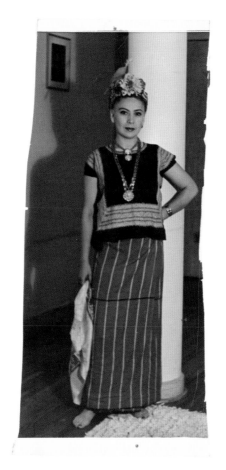

Left: Rosa Rolanda Covarrubias, an American dancer, is shown wearing traditional Tehuana dress. She married Miguel Covarrubias, a Mexican illustrator and caricaturist and good friend of Muray's in New York. Frida and Diego socialized with the couple when they moved to Tlalpán.

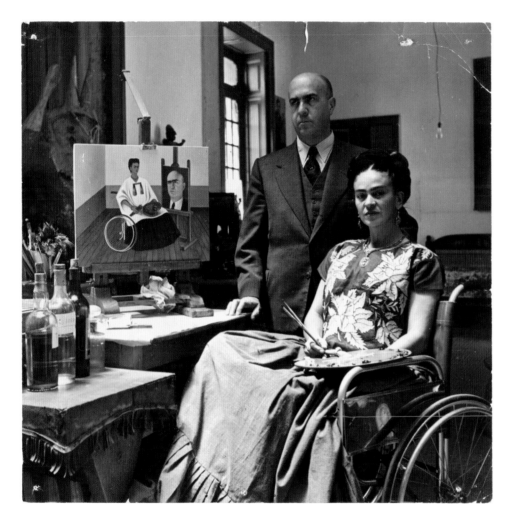

"Doctor Farill saved me. He brought me back the joy of life. I am still eager to live.
I've started to paint again. A little picture to give to Doctor Farill...with all my love."

Frida, in her diary, about her 1951 portrait of Juan Farill, M.D.

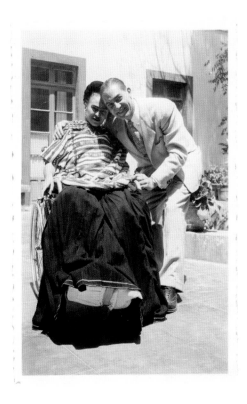

"*Feet, what do I want them for if I have wings to fly.*"

Frida, in her diary, 1953, on her decision to have her right foot amputated

Left: Frida after one of her many surgeries, photographed in a wheelchair

with a visitor in the courtyard of Casa Azul.

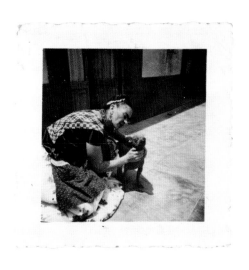

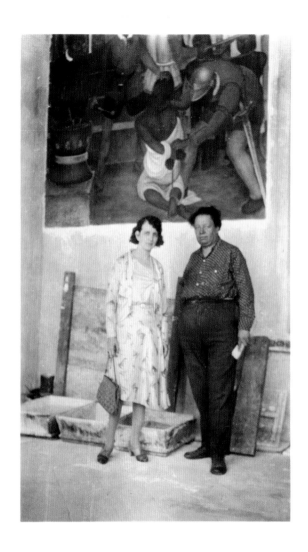

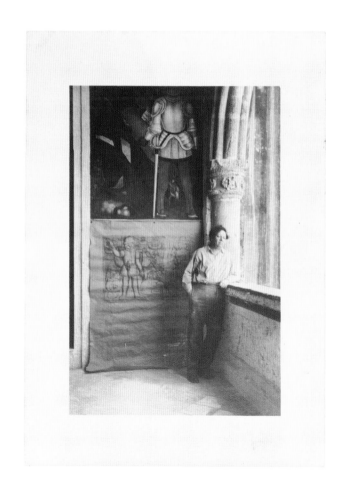

Left and above: Diego at the Palacio de Cortés, in Cuernavaca, Morelos, with his 1930 mural depicting the Mexican state's history from the Spanish conquest to Zapata's revolt.

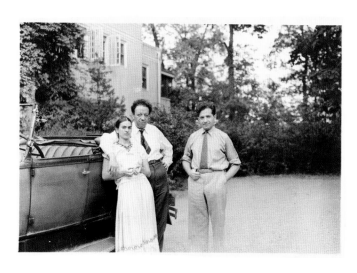

Above: In 1933, Lucienne Bloch took a portrait of Frida and Diego with a friend in upstate New York.

Below: Diego smiles down at Guadalupe Marín around 1921, when they began their relationship.

They would marry in 1922 and have two daughters, Guadalupe and Ruth.

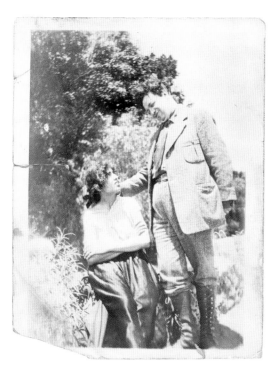

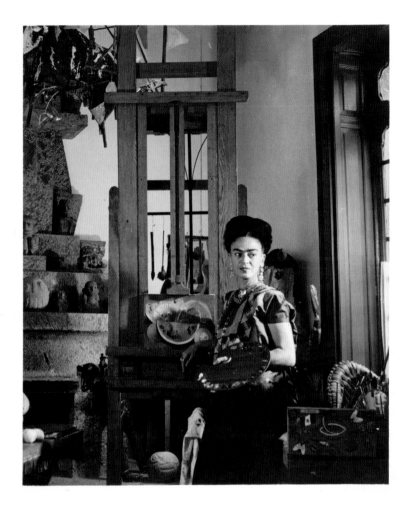

Frida, in her studio at Casa Azul, 1951. "*I never painted dreams, I painted my own reality.*"

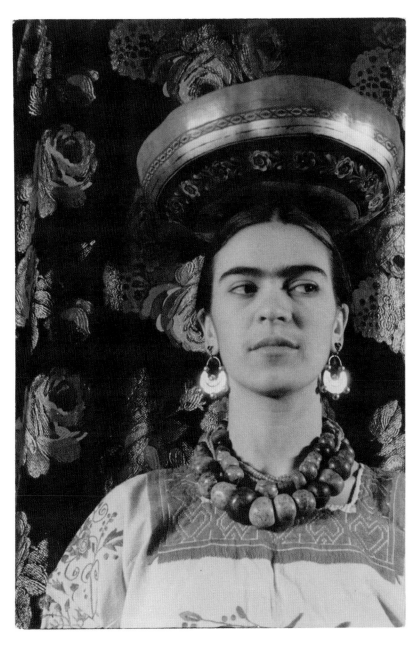

Frida, wearing a traditional cotton huipil, *balances a gourd on her head in the manner of the Mexican Indian women of Tehuana in a photograph taken in New York by Carl Van Vechten, 1932.*

In 1934, while preparing to repaint Man, Controller of the Universe *at the Palacio de Bellas Artes, in Mexico City,*
Diego studies Lucienne Bloch's clandestine photograph of the original mural in the RCA Building, Rockefeller Center, New York.
Work on the first mural was stopped when Diego
inserted V. I. Lenin's portrait without his patron's approval.

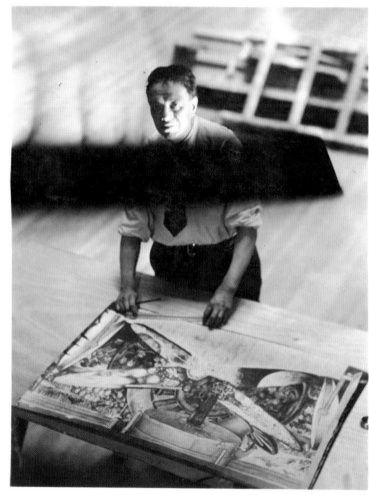

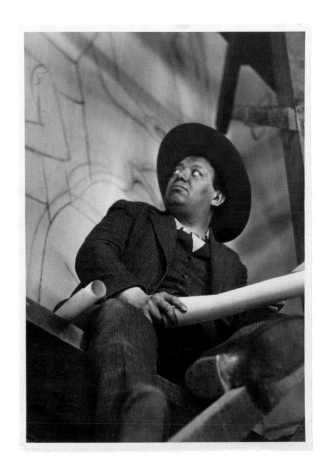

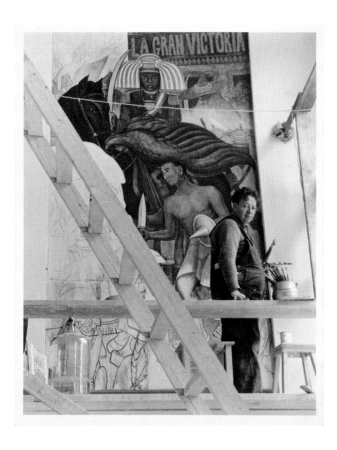

Above left: Diego paints Dance of the Huichilobos *in Mexico City's Hotel Reforma, 1936. Above right: On a scaffold at the Palacio de Cortés in Cuernavaca, Morelos, in 1929, Diego prepares to paint the mural commissioned by Dwight W. Morrow, United States ambassador to Mexico, as a personal gift to the Mexican people.*

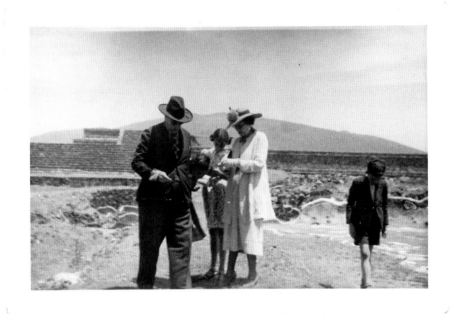

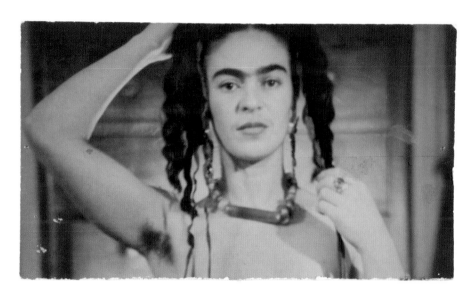

Frida tore this photograph to crop her topless portrait taken by the gallery owner Julien Levy in New York.
He inscribed on the back: "Pour Frida, souvenir dramatique / Julien Levy, Nov. 1938."

Below: An adorned Frida whistles on a boat ride in Xochimilco, Mexico City.
Right: Frida holds a sculpture by Mardonio Magaña in a photograph taken
by Guillermo Davila in the Coyoacán district of Mexico City, 1930.

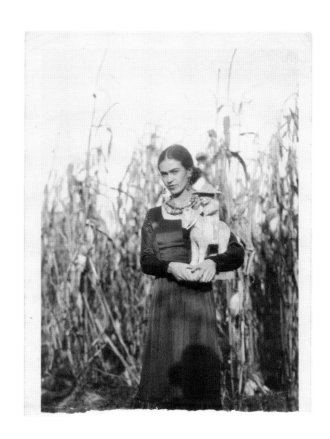

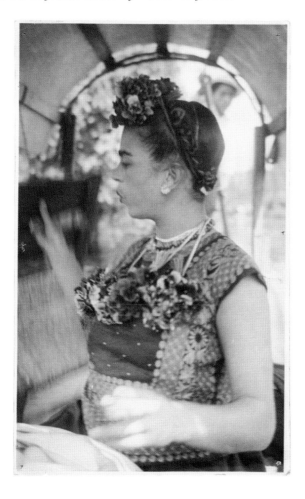

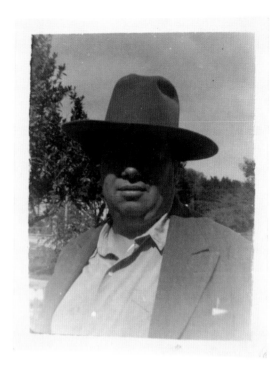

Above: "Diego—1928, cuando lo conocí [Diego—1928, when I met him]"
was written by Frida on the back of the photograph.

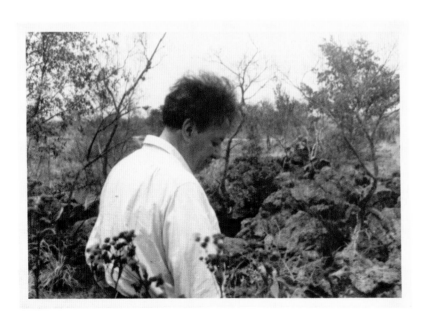

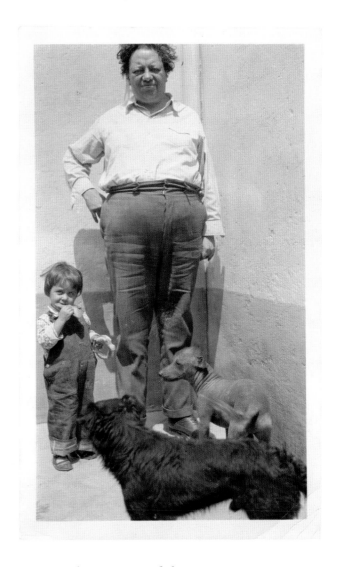

"I have suffered two serious accidents in my life,
one in which a streetcar ran over me The other accident is Diego."

Frida, in a conversation with a friend

The tiny model for the 1939 painting Girl with a Mask *stands in the doorway as Diego works on her portrait.*

Diego sits with Frances Rich, center, and her mother, Irene Rich, the American film star
and one of his patrons. Frances, a sculptor, was portrayed by Diego with a statue
of Saint Francis of Assisi, one of her favorite subjects.

Guillermo Kahlo, Frida's father, took this family portrait in Coyoacán, Mexico City, four months after her terrible trolley accident. Frida rests her arm on her uncle's shoulder. Her mother, Matilde, is at the center of the group, and her sister Cristina is on the rug in the foreground. "Frida vestida con el traje de papa [Frida wearing her father's suit]" is inscribed on the front.

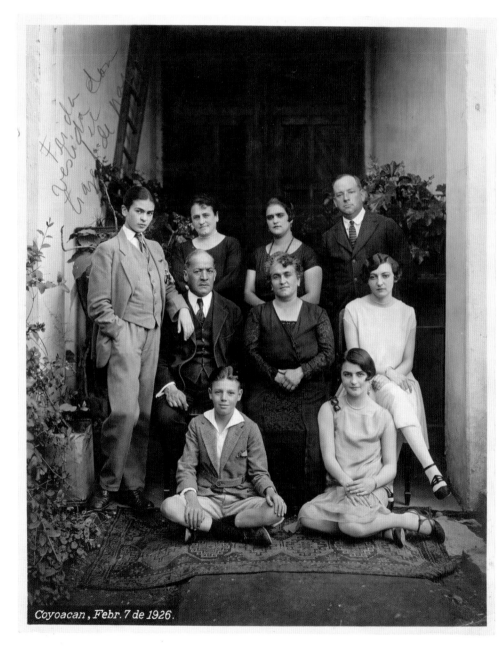

Coyoacan, Febr. 7 de 1926.

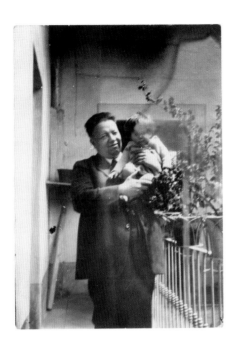

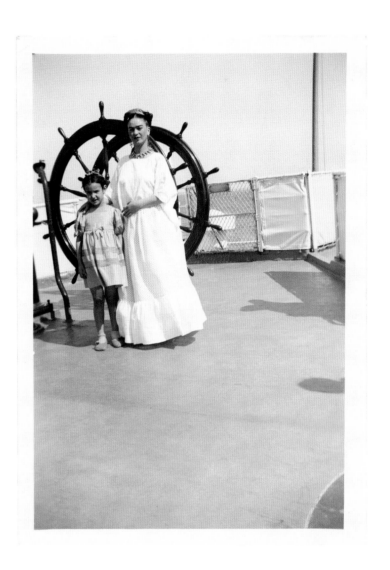

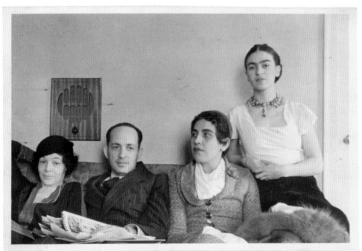

Left: Frida, far right, Guadalupe Marín Rivera (beside Frida), and an
unidentified couple were photographed by Lucienne Bloch at the Barbizon Plaza Hotel, New York, in 1933.

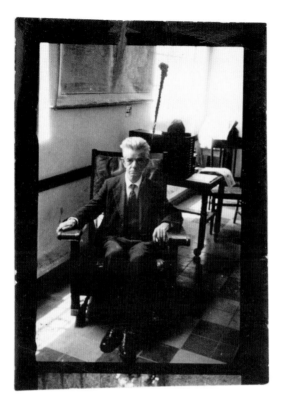

The self-portrait of Guillermo Kahlo was taken on July 22, 1932. Frida would inscribe on her 1951 painting Portrait of My Father:

"*I painted my father, Wilhelm Kahlo, of Hungarian-German origin, artist-photographer
by profession, in character generous, intelligent, and fine, valiant because he suffered for
sixty years with epilepsy but he never stopped working and he fought against Hitler.*"

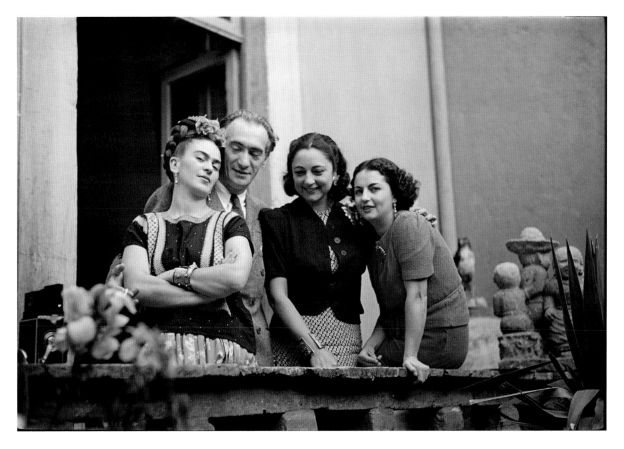

Nickolas Muray is between Frida and Rosa Covarrubias—Frida's sister Cristina is far right—
in a color photograph taken by Muray on the balcony of Casa Azul in 1939.

*"Why must I be so stubborn and dense as not to understand that the letters, the skirt-chasing,
the 'English' professors, the gypsy models, the 'goodwill' assistants, the disciples interested in the 'art of painting,'
and the 'plenipotentiary envoys from distant parts' only signify amusements
and that at bottom you and I love each other very much?"* Frida, in a letter to Diego, 1935

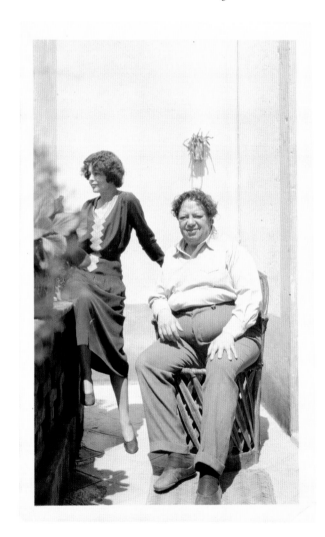

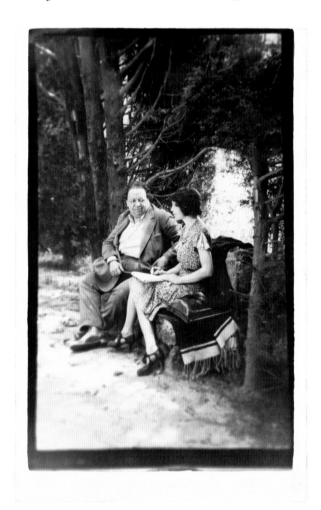

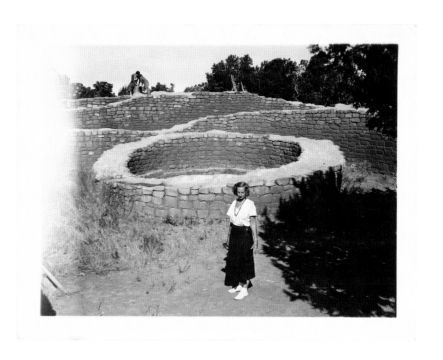

Above: At the Sun Temple, Mesa Verde National Park, Colorado. Below: Overlooking the Grand Canyon, Arizona.

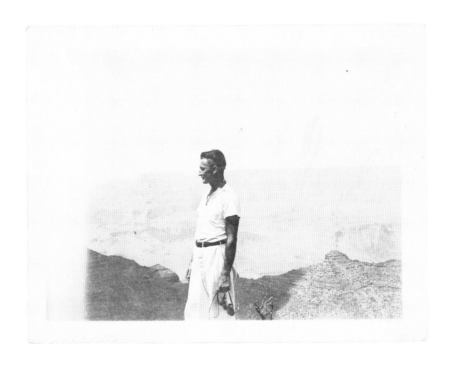

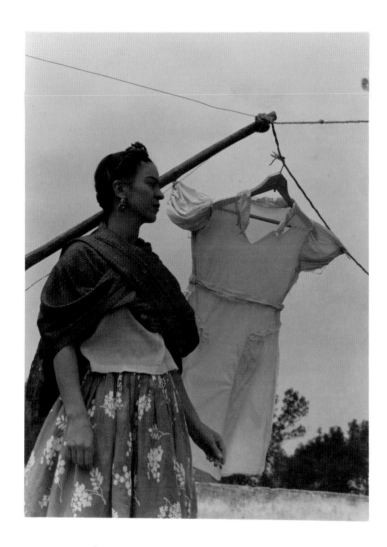

Manuel Álvarez Bravo portrayed Frida outdoors with a dress on the line in Coyoacán around 1937.
Frida often portrayed her outfits empty in her paintings.

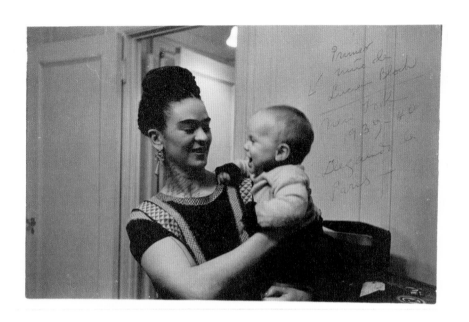

Above: Frida and her godson were photographed by Lucienne Bloch in New York in the late 1930s;
the baby is George Ernst Dimitroff, Bloch's first child with Stephen Dimitroff, who was also one of Diego's assistants.
Frida's scribbles try to mask the strong tendons in her neck and make her arm look slimmer.
Left: Frida, right, and her younger sister, Cristina, in 1926.

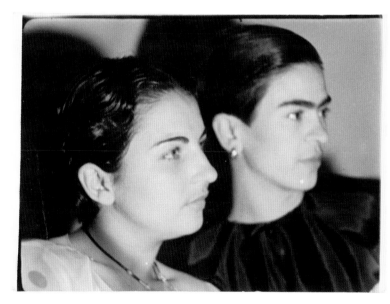

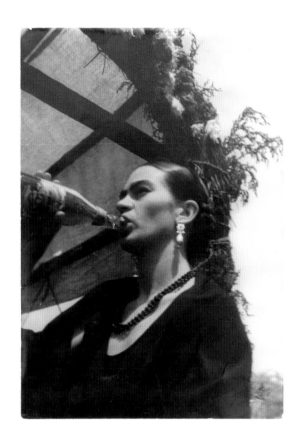

Above: An unknown photographer captured Frida drinking from a bottle on a boat in Mexico City in 1931.
Below: A pregnant Frida plays with a dog in Coyoacán, Mexico City, in 1930.

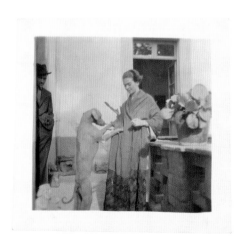

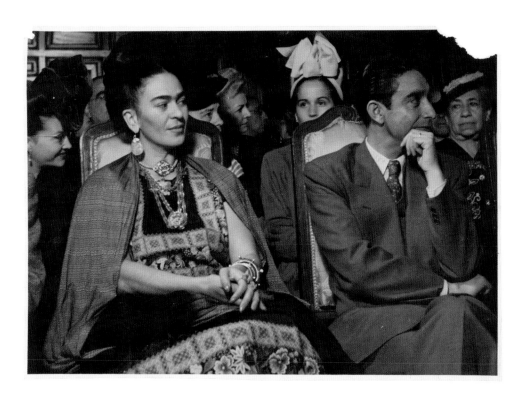

Frida, wearing one of her typical Mexican dresses and an array of jewelry, sits next to Julio Castellanos.

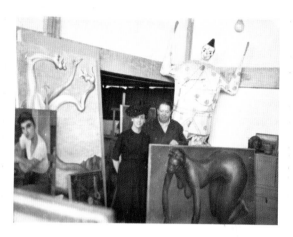

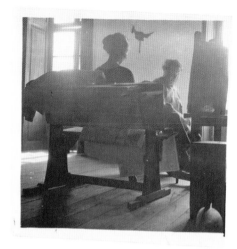

Above right: The 1939 painting Dance of the Earth *is in the foreground of Diego's studio.*

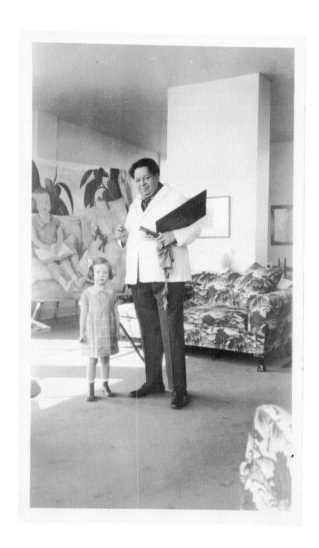

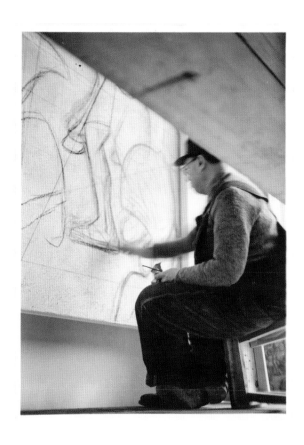 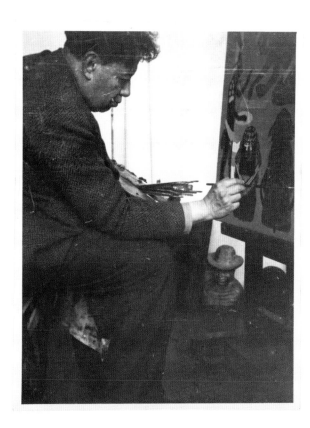 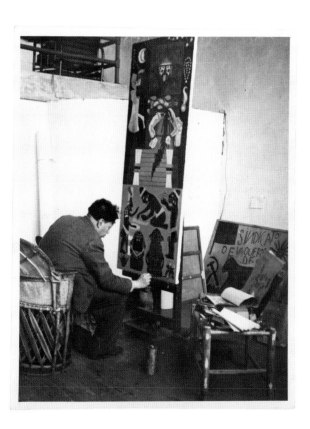

"Diego, my love, don't forget that as soon as you finish the fresco we shall be together forever, without quarrels or anything, only to love each other very much.... I adore you more than ever. Your child, Frida" Frida, in a letter to Diego, San Francisco, November, 1940

Besides the loose photographs in the Vicente Wolf collection, there is an album considered to be Diego Rivera's personal album. The facsimile printed here, with its empty spots and pages, is as it looked when acquired by Vicente Wolf in 2003. Included are some early photographs of Diego and Guadalupe Marín, his second wife, and probably of one of their daughters. The other pages are filled with typical pictures of smiling friends gathered during outings in various locales such as churches, street scenes, and ruins. Diego loved traveling to the different regions of Mexico to observe Indians for inspiration for his paintings, and these photographs have a watchful quality that would have suited such a purpose. Even if the album had not been identified as Diego's, its photographs seem to predate the majority of Frida's loose pictures—and it does not appear to hold any photographs of her. Perhaps she had gently absconded with the album so that she could hold on to more of Diego, to possess the Diego who existed before she knew him. Frida kept photographs of herself and her loved ones close by to comfort her, especially when she was laid up in bed for long periods of time at Casa Azul; she pinned her favorites to the headboard and walls. She also took the photographs with her on her numerous hospital stays, sometimes entrusting them, and the album, to her dear friend Leo Eloesser, M.D., who was also her most trusted doctor. They met in 1930 on her first trip to San Francisco, when she made an appointment to consult with him on her medical condition. The doctor, who became her closest confidante and convinced Diego to marry her a second time, would examine, operate on, and advise her for the rest of her life.

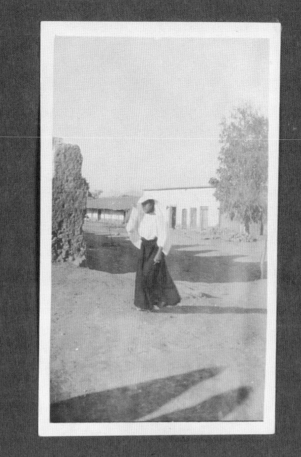

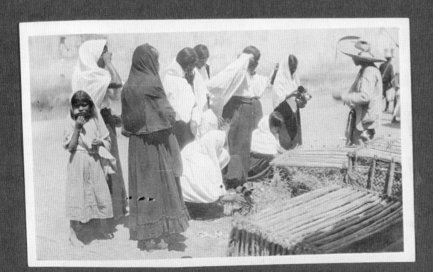

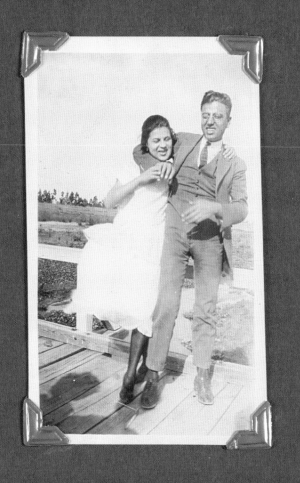

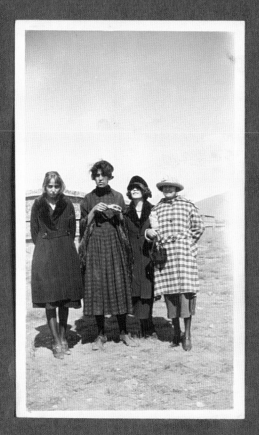
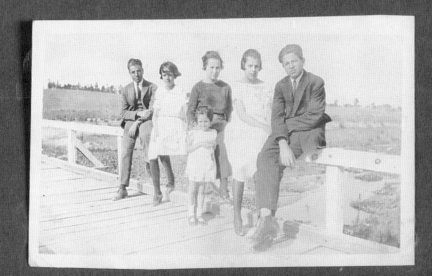

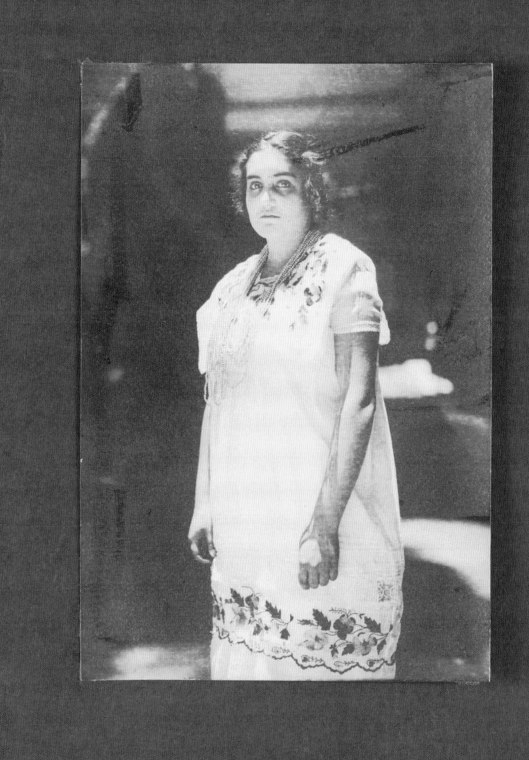

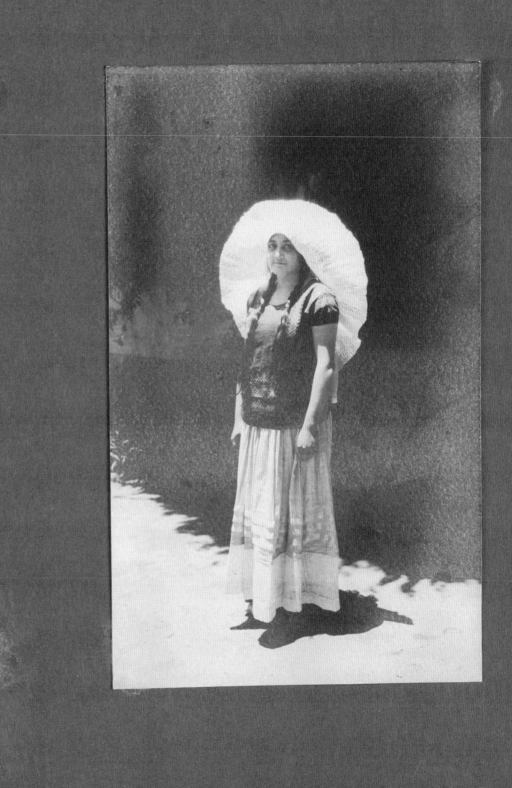

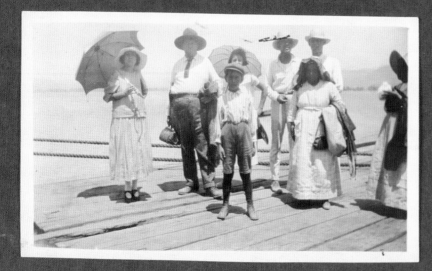

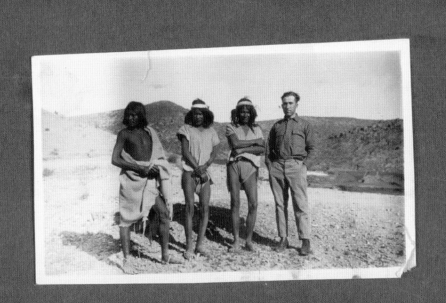

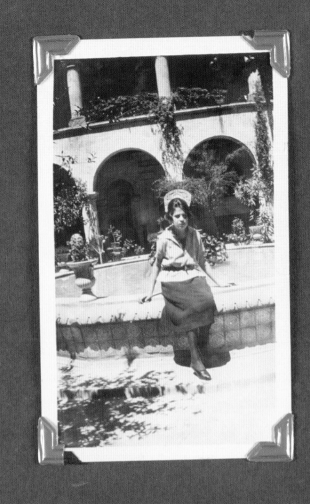

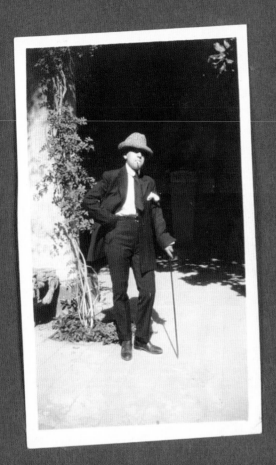
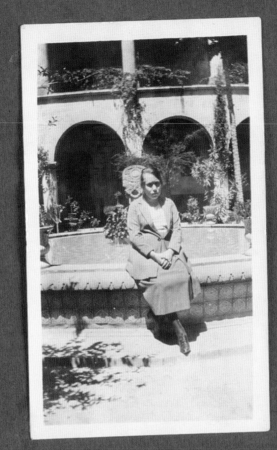
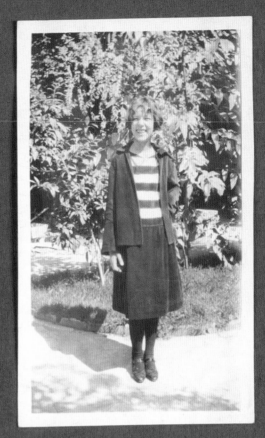
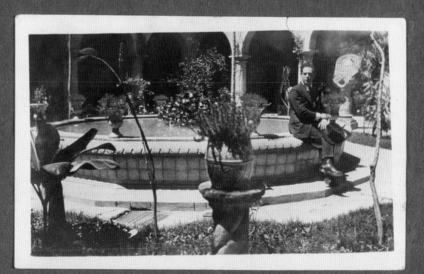

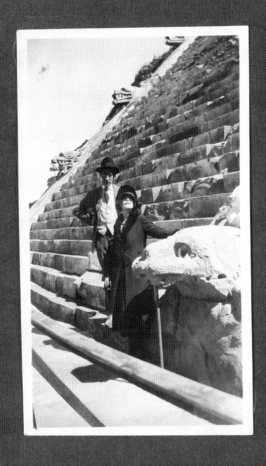

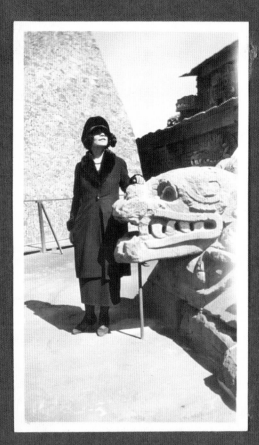

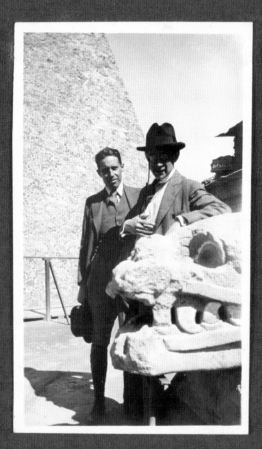

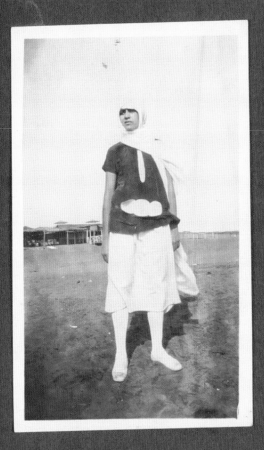

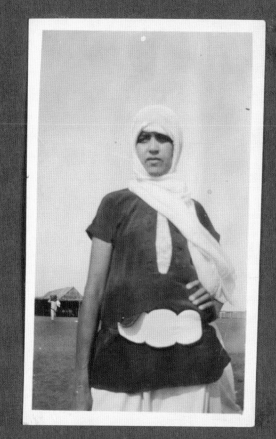

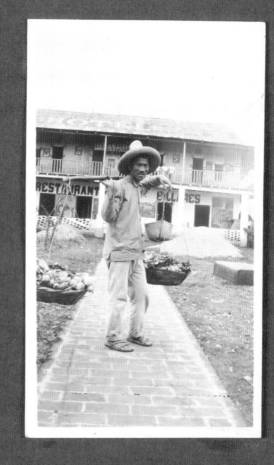

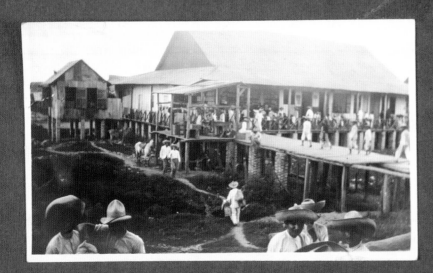

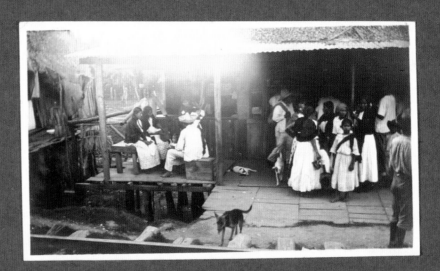

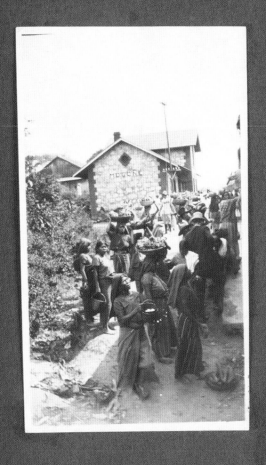

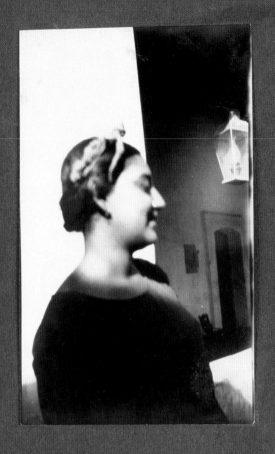
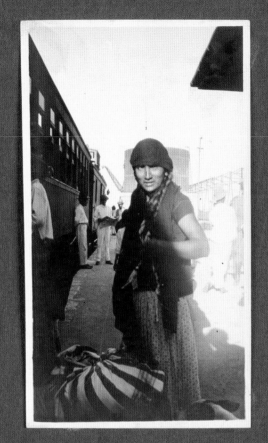
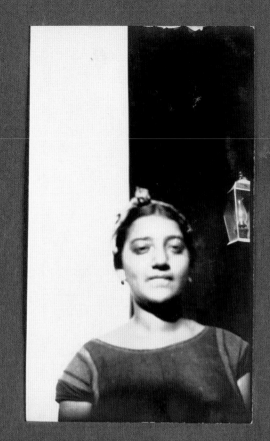

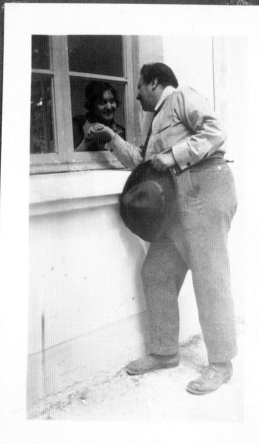
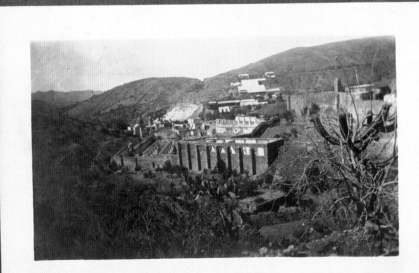

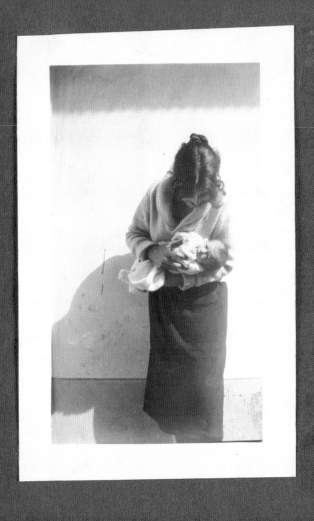
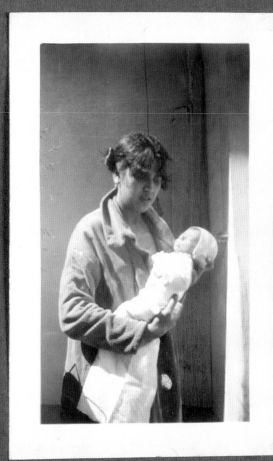

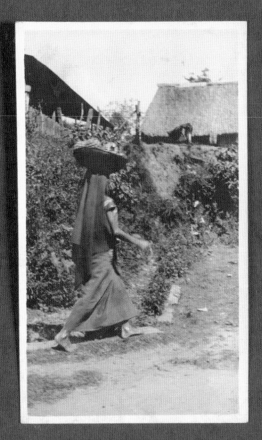

Diego working on the north wall of the Detroit Industry *mural at the Detroit Institute of Arts in 1933.*

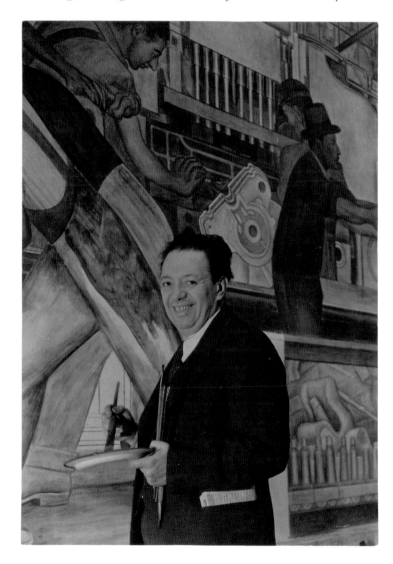

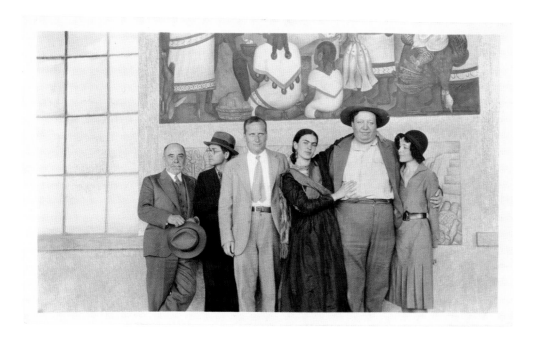

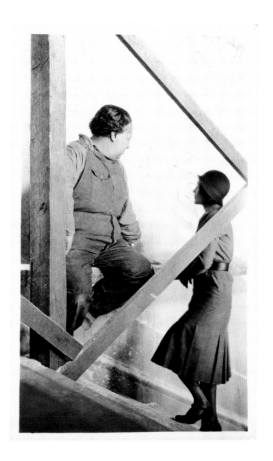

Above and above right: Frances Flynn Paine visits Diego, who was working on
The History of Mexico: From the Conquest to the Future *at the Palacio Nacional, Mexico City, in 1931.*

Diego and Frida on an outing aboard the Adelita, *in Xochimilco, Mexico City, around 1941.*

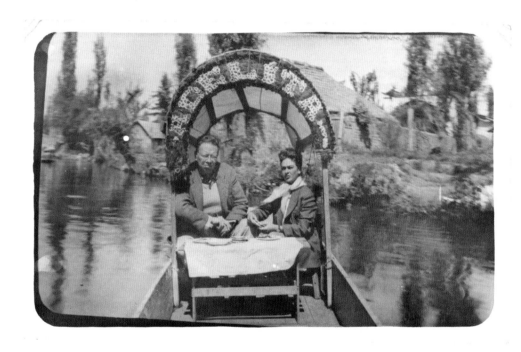

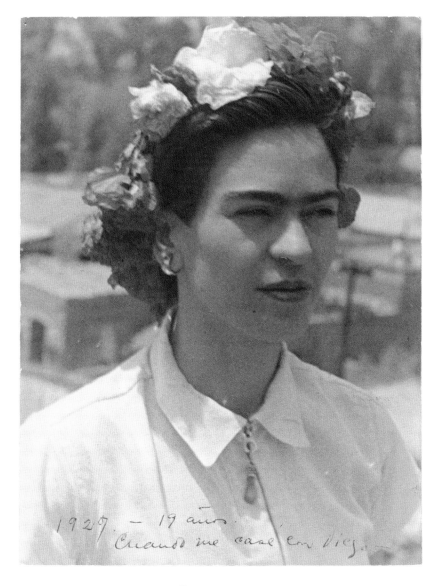

"1929—19 years old, when I married Diego." A translation of Frida's inscription on the photograph.

Frida was actually twenty-two when she married Diego on August 21, 1929, in Coyoacán.

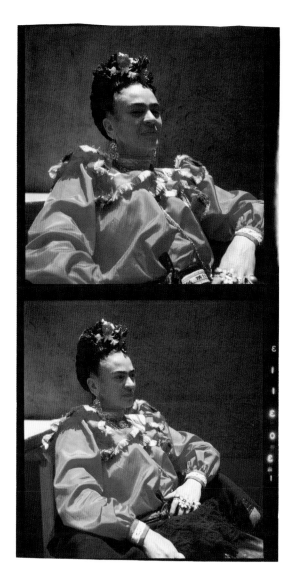

Frida was photographed in 1944 or 1945 by her friend Lola Álvarez Bravo, the first wife of Manuel Álvarez Bravo.
Lola would give Frida her first one-person show in Mexico, in 1953, the year before her death.

Frida poses in a long woven cotton coat from Guatemala.

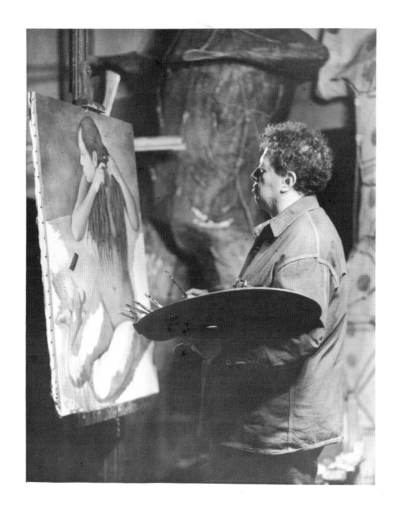

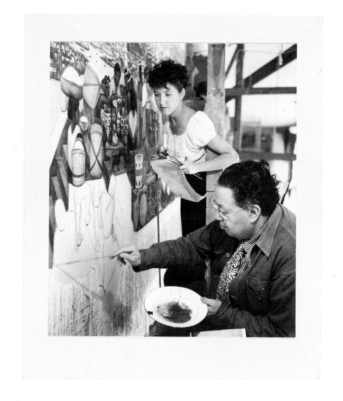

Above: Diego works on his 1939 painting Modesta Combing Her Hair.
Right: Diego and his assistant Violet work on his mural The Great City of Tenochtitlán
in the patio corridor of the Palacio Nacional, Mexico City, in 1945.

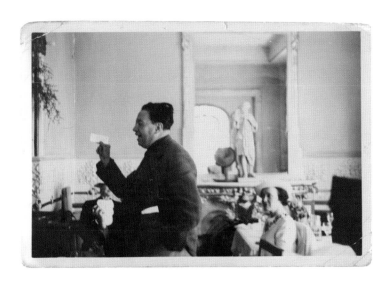
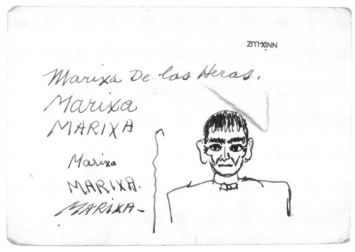

It appears that Frida has drawn and written on the back
of this photograph of Diego speaking at a restaurant.

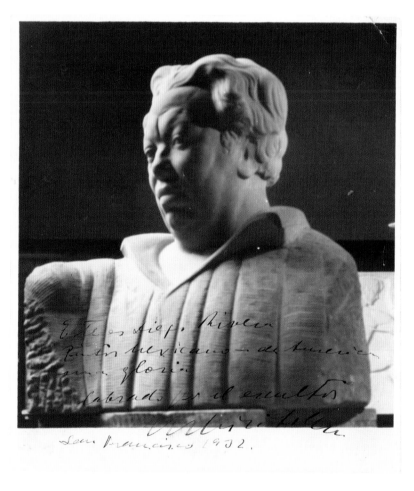

The bust of Diego by the Spanish sculptor Urbici Soler was completed in 1931.

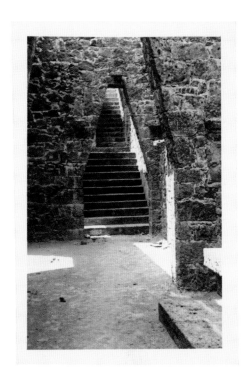

"*[My] second dream, one of thirty-five years' standing, was … to build a home
for my anthropological collection, which I had started to assemble on my first
return to Mexico in 1910…. The site we chose was near Coyoacán, right on top of
a lava bed…. We cut our stone from the basalt indigenous to the region. The structure
would rise from the earth like an extension of its natural surface. I designed the
building in a composite of Aztec, Mayan, and 'Rivera Traditional' styles. The squarely built
exterior resembles an ancient Mexican pyramid of the pre-Cortés period.*"

Diego Rivera, My Art, My Life: An Autobiography, *1945*

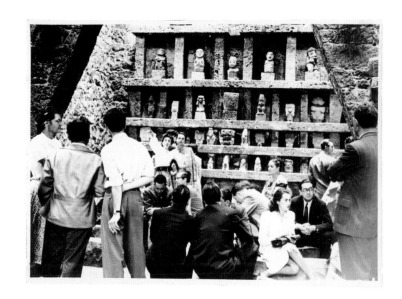 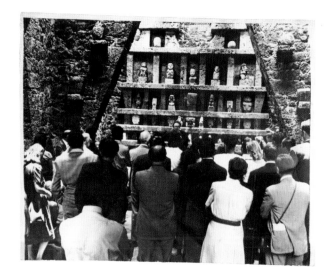

"His treasure is a collection of marvelous sculptures, jewels of indigenous art—the living heart of the true Mexico—that he has been able to collect over more than thirty years, with enormous economic sacrifices, to then display it in a museum that he has been building for the last seven years. This enterprise he has realized with his own creative and economic forces, i.e., with his marvelous talent and with what he receives for his paintings. He will donate it to his country, offering to Mexico the most prodigious source of beauty that has ever existed." Frida, "Portrait of Diego," 1949

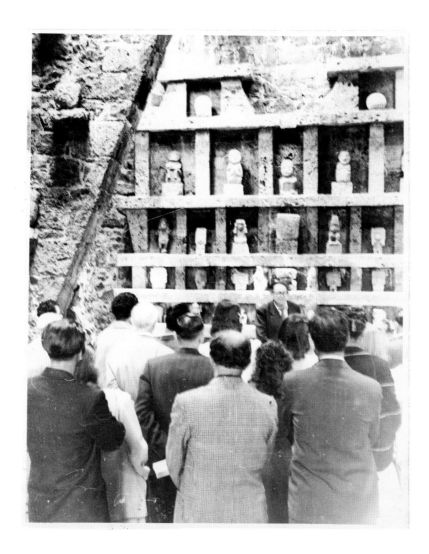

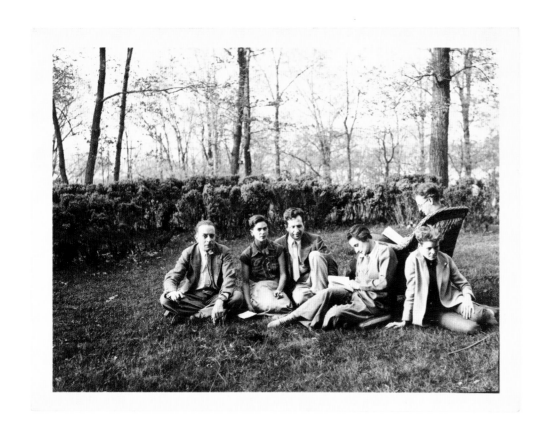

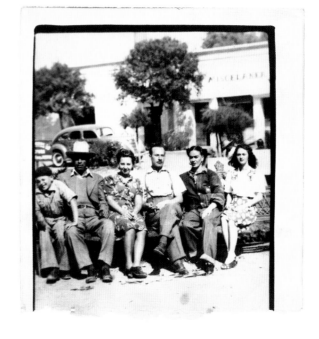

Above right: In 1943, Frida, wearing men's dungarees, sits between
Pedro Infante and her niece Isolda Kahlo; her nephew Antonio Kahlo
is at far left, next to two unidentified people.

One of Frida and Diego's close friends was Miguel Covarrubias, shown relaxing with them in about 1935.

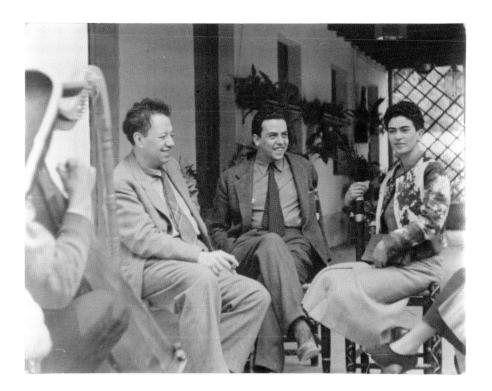

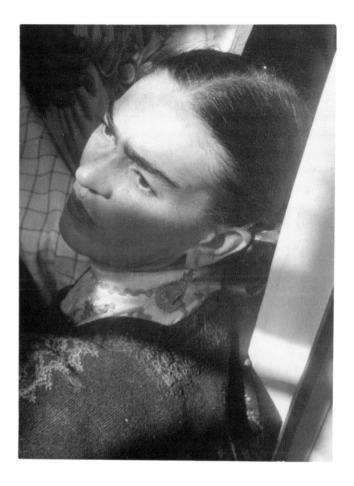

"*I am not sick, I am broken. But I am happy to be alive as long as I can paint.*"

<div style="text-align:right">*Frida*, Time, 1953</div>

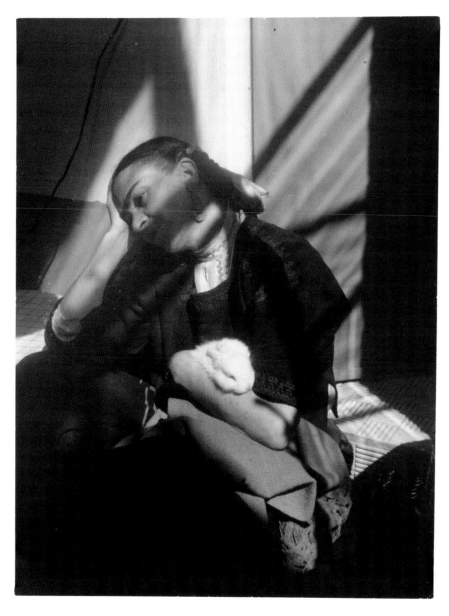

Opposite and above: Hector García, a well-known Mexican photojournalist,

took these pictures of Frida at Casa Azul in 1949.

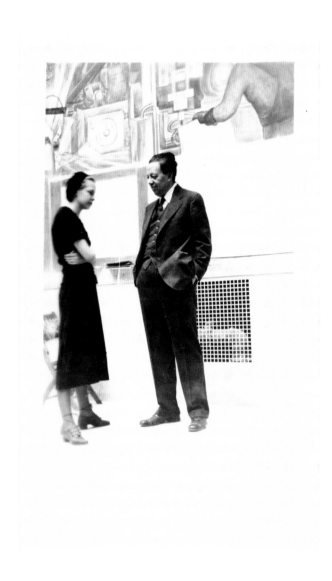

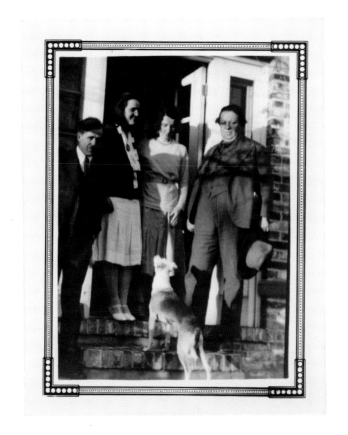

Above, from left: The sculptor Ralph Stackpole, an unidentified woman,
Stackpole's wife, Ginette, and Diego. Stackpole was influential in bringing
Diego to San Francisco for his first commissions there. Right: Translation of the text
on the back of this 1931 photograph taken in Santa Rosa, California: "Here is Diego with Mrs. Stackpole, then Mrs. Burbank,
and Ralph Stackpole last. Mrs. Burbank is very simple and nice and must have been a very beautiful woman,
now she is forty or forty-five, but when she married Burbank she was twenty-two and he was sixty-nine."

Diego, June 21, 1938.

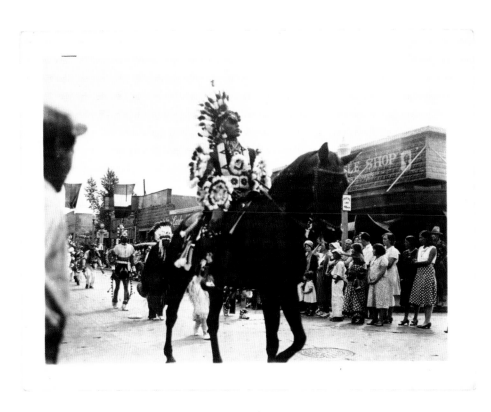

Sioux Indians, Laredo, Texas, around 1932.

 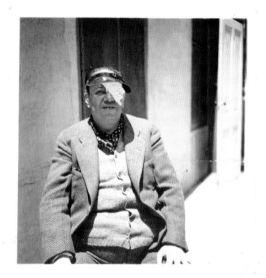

The problems Diego had with his eyes throughout his life were compounded by the long hours he spent painting.

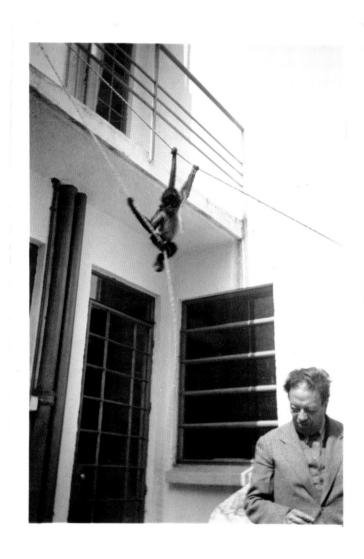

Diego with one of the pet spider monkeys at San Angel.

"With his Asiatic-looking head with the dark hair growing on it so thin and fine that it seems to be floating in the air, Diego is a giant child, with a friendly face and a rather sad gaze.

His prominent, dark, highly intelligent, big eyes are barely still ... and are set far apart from each other, more so than other eyes. It was almost as if they were constructed exclusively for a painter of vast spaces and multitudes. Between these eyes ... can be glimpsed the invisibility of Oriental wisdom, and only seldom does the ironical and delicate smile, the flower of his portrait, disappear from his Buddha-like mouth with its fleshy lips." *Frida, "Portrait of Diego," 1949*

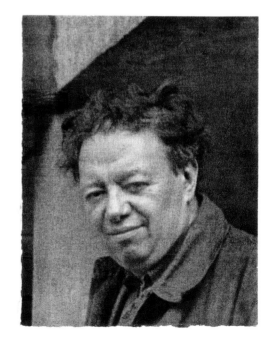

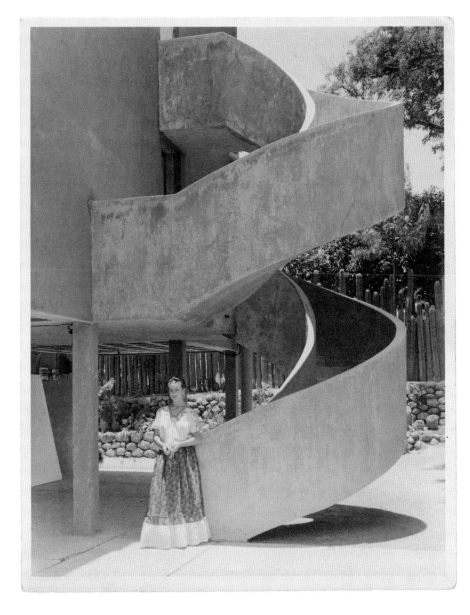

Frida at the staircase behind Diego's studio in the San Angel compound designed by their friend,
the Mexican architect Juan O'Gorman. The modernist home-studios were built in
1931 and 1932 with Diego's earnings from his San Francisco murals.

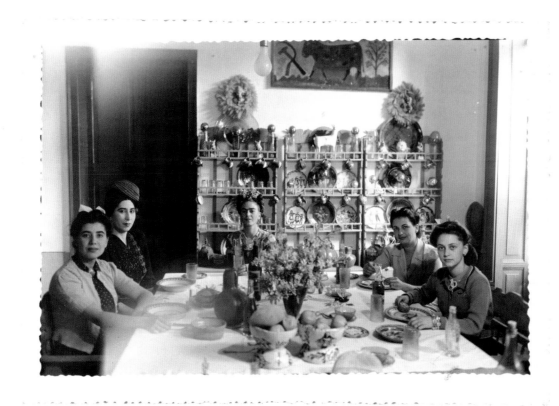

From left: Guadalupe Marín Rivera, an unidentified friend, Frida, her sister Cristina,
and Cristina's daughter Isolda in the dining room of Casa Azul around 1942.

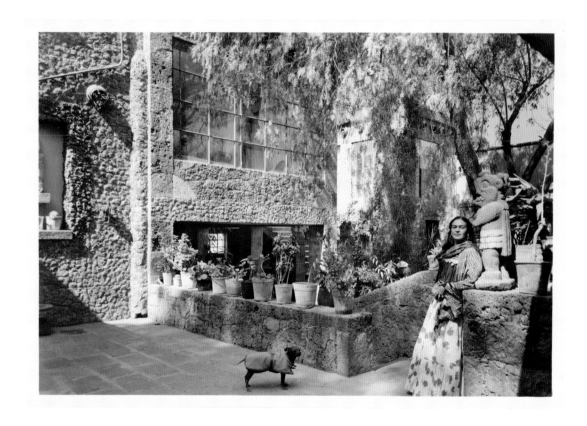

In 1951 or 1952, Frida, with her hair down, leans against one of Diego's pre-Columbian artifacts in the plant-filled courtyard of Casa Azul.

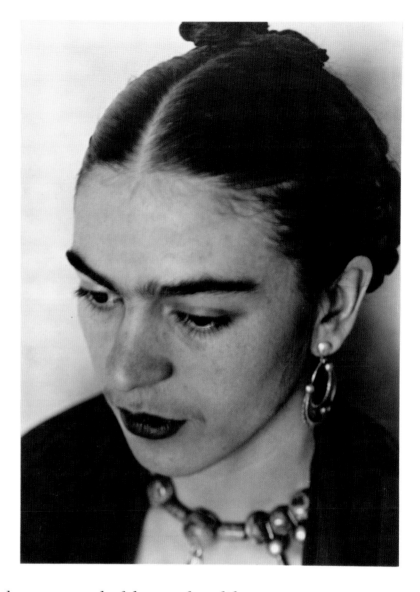

"Too late ... I realized that the most wonderful part of my life had been my love for Frida." *Diego Rivera*, My Art, My Life: An Autobiography

*Frida plays a guitar in 1929 or 1930. When she was in Paris for her
painting exhibition in 1939, Pablo Picasso taught her a Spanish song
that she enjoyed singing with her friends back in Mexico.*

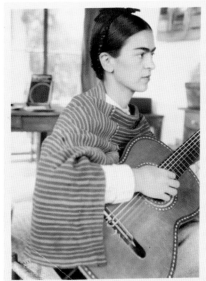

"Anguish and pain—pleasure and death are no more than a process for existence." Frida, in her diary, 1947

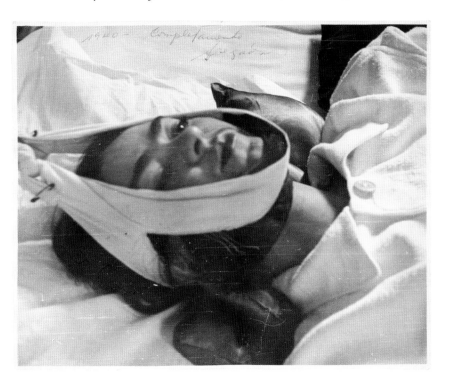

Nickolas Muray photographed Frida in traction in a Mexico City hospital.
She wrote on the front: "1940 Completamente fregada [Completely messed up]."

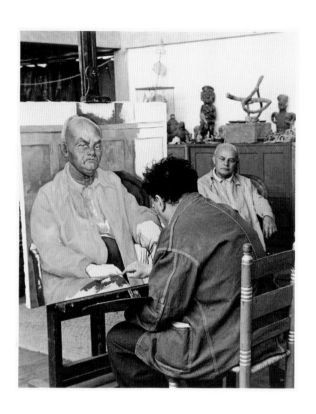

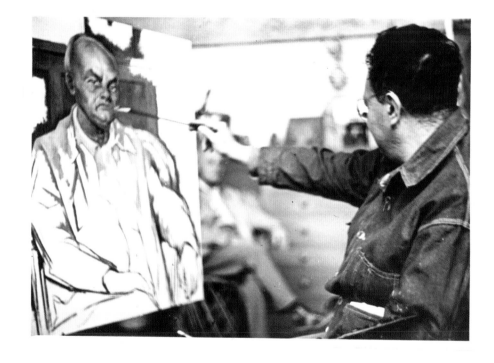

Above and above right: Diego paints the portrait of the German Marxist Otto Rühle in 1940.
Rühle was a member of the Dewey Commission's 1937 hearings at Casa Azul.

Below left: Diego and John Dunbar, the New York real estate mogul, in the studio
with his 1931 portrait. Below right: Mrs. Makar-Batkin sits for Diego in 1929.

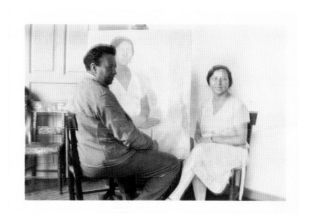

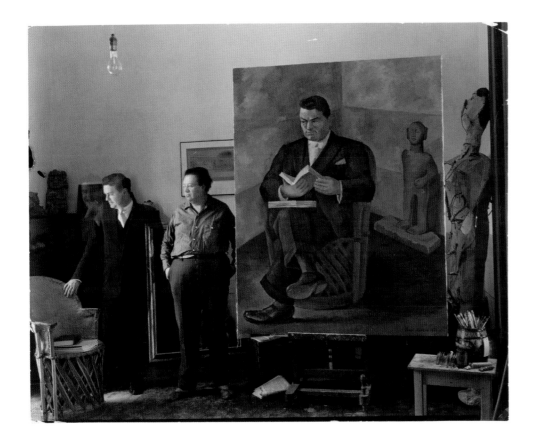

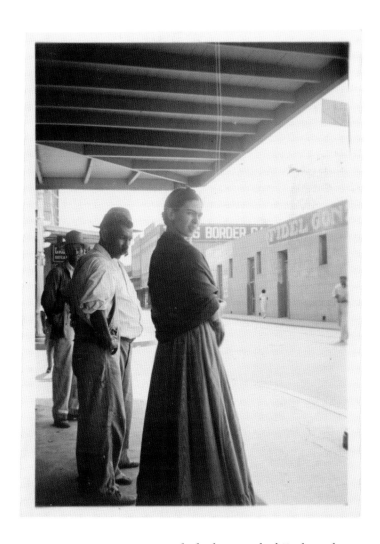

Lucienne Bloch photographed Frida as they waited for a train in Laredo, Texas.
Bloch accompanied Frida on the long journey home from Detroit in September 1932
so that she could be with her dying mother.

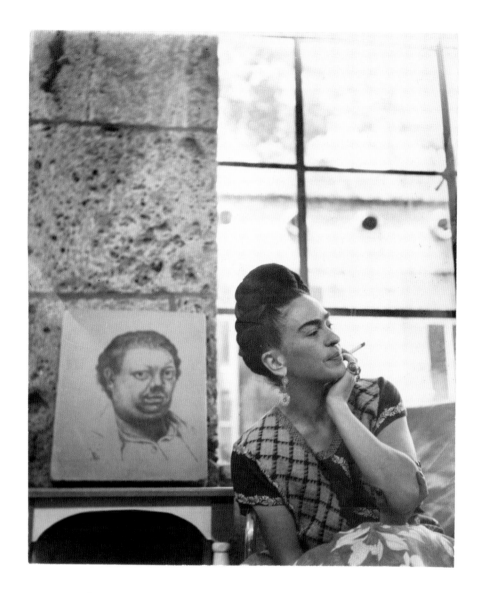

"*I began to paint things that he liked. From that time on, he admired me and loved me.*" Frida, written before she and Diego were married.
Above: Lola Álvarez Bravo photographed her friend around 1945 at Casa Azul, with Diego's 1930 Self-portrait on a lithographic stone nearby.

"No one will ever know how I love Diego. I don't want anything to wound him,
nothing should bother him or take away the energy that he needs to live—to live the way
he wishes, to paint, see, love, eat, sleep, to feel himself alone, to feel himself
accompanied—but I would like to give all to him. If I had health, I would like to give it all to him.
If I had youth, he could take it all." *Frida, in her diary, 1947*

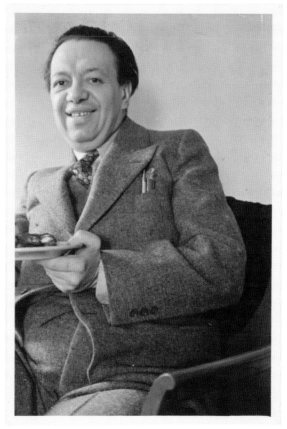

CHRONOLOGY

1907 Magdalena Carmen Frida Kahlo Calderón, the third of four daughters, is born on July 6 in the home built by her father on the corner of Londres and Allende streets in Coyoacán, a suburb of Mexico City. Her father, Wilhelm Kahlo, had immigrated to Mexico from Germany as a young man and changed his name to the Spanish equivalent, Guillermo. Frida's mother, Matilde Calderón y Gonzalez, Guillermo's second wife, was born in Oaxaca of Spanish and Indian descent. Matilde's father took Guillermo into his photography business. He became quite successful, which gave him the money to build Casa Azul, as Frida's lifelong home would be called.

1910 Start of the Mexican Revolution. Later, Frida would change her birth year to 1910 to coincide with the beginning of the new political climate.

1914 Frida, six years old, is stricken with poliomyelitis. Her right leg and foot will be permanently stunted and her muscles weakened. Over time, Frida learns to disguise the resulting limp and wears long skirts to hide her shriveled leg.

1922 Frida, as a teenager, attends the prestigious Escuela Nacional Preparatoria, where she enrolls in premed studies. She becomes part of a small, elite group of highly intellectual students, "Los Cuchachos," who were famous for their tricks and wit. She soon wins over their leader, Alejandro "Alex" Gómez Arias, as her boyfriend and close companion for several years. The famous painter Diego Rivera is commissioned to do a mural at the government school. Frida takes notice of him, pulls a few pranks, and consequently gets herself noticed by the much older artist. Her poem "Recuerdo" ("Memory") is published in a literary journal.

1924 Frida begins to help her father after school with his photography business. She accompanies him on location because he is epileptic and works in his studio, retouching.

1925 Early in the year, Frida apprentices with an engraver and trains in drawing. On September 17, Frida and Alex are riding home from school in a bus when a trolley plows into their vehicle. She is severely injured: Several vertebrae are damaged, assorted bones are broken, her right leg and foot are crushed, and an iron handrail pierces the left side of her pelvis and vagina. Arias is hardly hurt and helps rescue her, saving her life.

1926 She slowly starts to paint during the long recovery, when her mother has an easel designed to fit on Frida's bedstead and a mirror mounted nearby. She also starts her lifelong habit of writing letters, many to Arias, who goes back to school and, eventually, on with his life. Frida also begins to paint portraits of her friends and family, as well as the *Self-portrait Wearing a Velvet Dress* to entice her boyfriend back. She experiments with men's clothing to hide her bad leg and cuts her hair short. During much of the year, she is forced to wear metal and plaster casts to offset back problems that develop because of the accident.

1927 Frida joins the Young Communist League.

1928 Frida meets Tina Modotti, a young photographer with similar political views. Modotti reacquaints Frida with Diego, a fellow Communist. He admires her painting and portrays Frida as an active member of the Mexican Communist Party in a mural about the Mexican Revolution at the Ministry of Public Education.

1929 Diego and Frida marry in the town hall of Coyoacán on August 21. Frida is 22; Diego, 42. He is expelled from the Communist Party for accepting mural commissions from the Mexican government, and Frida resigns in protest.

1930 Frida terminates her first pregnancy because of damage to her pelvis from the accident. Diego and Frida travel to the United States when he gets a mural commission in San Francisco through the help of a friend, the sculptor Ralph Stackpole. Frida meets Edward Weston and Imogen Cunningham, who photograph her, and Albert Bender, an art patron. Frida makes an appointment with Leo Eloesser, M.D., a famous thoracic surgeon.

1931 Frida paints *Frida and Diego Rivera,* which is shown at the Sixth Annual Exhibition of the San Francisco Society of Women Artists, her first show. She also paints portraits of Dr. Eloesser, as a gift for him, and Luther Burbank. On their return to Mexico, Diego hires a friend, the architect Juan O'Gorman, to design two connected home-studio buildings in San Angel, a district of Mexico City. The Museum of Modern Art offers Diego a one-person retrospective, so the couple sails to New York in November. Frida meets Lucienne Bloch, a young muralist and photographer hired as Diego's assistant. The two women become close friends.

1932 Diego and Frida move from New York to Michigan so that Diego can research and paint a series of murals, *Detroit Industry,* at the Detroit Institute of Arts, paid for by Edsel Ford and other industrialists. Bloch travels to Detroit to help when Frida has a miscarriage on July 4. In September, Bloch accompanies Frida on the long train trip back to Mexico City to attend to her mother, who dies a week after Frida arrives home. She spends a month with her father before returning to Detroit with her friend. Frida paints her traditional Mexican clothing in *My Dress Hangs There* and depicts her miscarriage in *Henry Ford Hospital.* The home-studios in San Angel are built.

1933 The couple moves back to New York. Diego is commissioned by Nelson Rockefeller to paint a mural in the RCA Building, and Bloch again assists him. Diego is fired for including a portrait of V. I. Lenin; the portrait was not part of the original, approved sketch. Bloch smuggles her camera onto the scaffolding to record the mural as work is shut down. The painting is eventually destroyed, as is Diego's mural-painting career in the United States. The Socialist New Workers School offers Diego space to work, and he paints a revolutionary history of the United States for free. In December, the couple sails home.

1934 Frida suffers through more surgery, including another abortion due to a problem pregnancy. She and Diego move in to the compound in San Angel. Diego receives a commission to re-create the RCA Building mural in Mexico City. Frida cuts her hair short after discovering that Diego is having an affair with her sister Cristina.

1935 Frida separates from Diego and paints *A Few Small Nips.* She has an affair with the Japanese-American sculptor Isamu Noguchi when he travels to Mexico. She moves back to San Angel.

1937 Diego helps the exiled Russian Bolshevik Leon Trotsky and his wife, Natalia, find asylum in Mexico and moves them in to Casa Azul. The Dewey Commission holds hearings there to clear Trotsky of the treasonous verdict of the Moscow Trials. Frida has a short liaison with Trotsky and dedicates a self-portrait to him. She meets the New York photographer Nickolas Muray, who is visiting Miguel Covarrubias, a Mexican illustrator, and his wife, Rosa, who are also friends of Diego and Frida's.

1938 André Breton, the French surrealist writer, and his wife, Jacqueline, take an extended trip to Mexico. Besides his solidarity with Trotsky and Rivera's politics, Breton is enamored of Mexican art, including family friend Manuel Álvarez Bravo's photographs and Frida's paintings, which he labels surrealist. He offers her a gallery show in Paris. Actor Edward G. Robinson buys four of her paintings. In October, she travels alone to New York for a successful one-woman show at Julien Levy's gallery. She has a brief affair with Levy, then begins a serious romance with Muray.

1939 Trotsky, who has a political falling out with Diego, vacates Casa Azul. Frida sails alone from New York to Paris for the gallery show promised by Breton, who has not followed up on his commitment. Marcel Duchamp helps to assemble a group show that includes Mexican folk art and works by Frida, Álvarez Bravo, Pablo Picasso, and Wassily Kandinsky; other artists and designers are impressed with Frida, her painting, and her style. The Louvre purchases *The Frame,* a self-portrait. While in Paris, she becomes ill and must be hospitalized. In New York, on the way home, she ends her relationship with Muray. She and Diego separate again, and she moves back to Casa Azul. They divorce in November. Juan Farill, M.D., prescribes traction for her spinal problems. She cuts her hair short in reaction to the divorce.

1940 Frida paints *Self-Portrait with Cropped Hair.* Breton mounts a surrealist exhibition in Mexico City that includes two of Frida's paintings. Diego becomes a suspect in an assassination attempt on Trotsky and flees to San Francisco. Frida's work is included in the Golden Gate International Exposition, and she has a painting in a show of Mexican art at the Museum of Modern Art in New York. Trotsky is assassinated in August, and Frida is detained because she had met the main suspect in Paris. Her pain worsens, so she follows Diego to San Francisco a few months later to seek treatment from Dr. Eloesser. Diego introduces her to Heinz Berggruen, who worked on the Golden Gate Exposition. They fall in love, and he meets her in New York as she tries to arrange another show at Levy's gallery. After Diego is made to understand the extent of Frida's physical suffering, he offers several proposals of marriage. She returns to San Francisco, and they remarry on December 8, his fifty-fourth birthday. Frida returns to Mexico and moves in to Casa Azul, where she will live for the rest of her life.

1941 Frida's father dies, and her depression worsens her health. Diego moves in to Casa Azul. Frida is included in a Mexican art show at the Institute of Contemporary Art in Boston and is invited to be a founder of the Seminario de Cultura Mexicana.

1942 Frida teaches at "La Esmeralda," a national arts school. Diego begins construction on a museum, which he calls Anahuacalli, to hold the pre-Columbian art and artifacts he has been collecting since his return from Europe as a young man in 1910. Frida helps raise money for the museum. She exhibits *Self-portrait with Braid* in a portrait show at the Museum of Modern Art in New York.

1943 Frida's health problems make teaching difficult. To continue studying with her, a core group of students, "Los Fridos," commute to Casa Azul. Her paintings are in several exhibitions: a women's group show at Peggy Guggenheim's Art of This Century Gallery in New York, a Mexican portrait show at the Benjamin Franklin Library in Mexico City, and a show of Mexican art at the Philadelphia Museum of Art.

1944 Frida's health declines, resulting in more surgeries and treatments. She continues to exhibit her work in group shows in the United States and Mexico. She begins a diary, which she continues until the end of her life. Frida paints *Diego and Frida 1929–1944* as a fifteenth-anniversary gift to her husband.

1946 Frida is accompanied by her sister Cristina to New York for another operation on her spine. Frida must wear a metal corset for eight months. The Ministry of Education gives her a national painting prize for *Moses,* an interpretation of Sigmund Freud's book *Moses and Monotheism.* She receives a fellowship from the Mexican government.

1947 Mexico City's Museum of Modern Art buys *The Two Fridas.* She has one painting in a show at Mexico City's National Institute of Fine Arts. Frida has a miscarriage; it is not Diego's baby.

1948 Frida returns to the Mexican Communist Party. Diego begins an affair with the Mexican actress Maria Félix and contemplates another divorce.

1949 Frida writes "Portrait of Diego" for the catalog of his fifty-year retrospective at the Palacio des Bellas Artes in Mexico City. She has a painting in the inaugural exhibition of the Salon de la Plástica Mexicana. Gangrene is detected in her right foot.

1950 Frida spends nine months in the hospital to undergo seven surgeries. She continues to paint.

1952 Frida begins to paint still life pictures of fruits in a new, looser style. She has been confined to a wheelchair since 1951 and becomes reliant on pain pills and morphine.

1953 The Tate Gallery in London includes some of her paintings in a show of Mexican art. At her gallery in Mexico City, Lola Álvarez Bravo, Manuel's former wife and Frida's dear friend, gives Frida her only solo exhibition in Mexico. Frida writes a poem for the invitation, her bed is moved to the gallery, and she arrives on a stretcher by ambulance for the opening, which is attended by a huge crowd. The show is held over by popular demand. In response to the gangrene, Dr. Farill recommends amputation of her right leg. After much deliberating in her diary, Frida accepts his advice.

1954 Frida endures two more hospital stays in the spring. In early July, she participates in a political rally with Diego and O'Gorman in the rain, even though she has pneumonia and is wheelchair-bound. On July 13, Frida dies at Casa Azul. She is forty-seven years old. After her sister and friends dress her and braid her hair, Lola Álvarez Bravo takes deathbed photographs of Frida. She lies in state at the Palacio de Bellas Artes. Diego has her cremated, puts her ashes in one of his pre-Columbian urns, and returns her to Casa Azul.

1955 Diego marries Emma Hurtado after he is diagnosed with prostate cancer. He bequeaths Casa Azul and Anahuacalli to the Mexican people.

1957 Diego dies in his San Angel studio. He wishes to have his ashes joined with Frida's, but instead he is buried in the Rotunda of Famous Men in Mexico City.

1958 Casa Azul opens to the public.

1986 The compound in San Angel opens to the public as the Diego Rivera Studio Museum.

SOURCES

Half Title: Frida Kahlo, *Frida by Frida* (Mexico: Editorial RM, 2006), p. 338.

Page 6: Hayden Herrera, *Frida Kahlo: The Paintings* (New York: Harper Collins, 1991), p. 151.

Page 7: Frida Kahlo, *The Diary of Frida Kahlo: An Intimate Self-portrait* (New York: Harry N. Abrams, 1995), p. 235.

Page 10: Denise and Magdalena Rosenzweig, eds., *Self Portrait in a Velvet Dress* (San Francisco: Chronicle, 2007), p. 51.

Martha Zamora, *Frida Kahlo: The Brush of Anguish* (San Francisco: Chronicle, 1990), p. 53.

Page 11: Frida Kahlo, *Frida by Frida* (Mexico: Editorial RM, 2006), p. 357.

Page 12: Cynthia Newman Helms, *Diego Rivera* (New York: W. W. Norton & Co., 1986), pp. 286–289.

Page 13: *Ibid.*, 1986, p. 290.

Page 14: Cynthia Newman Bohn, ed., *The World of Frida Kahlo* (Houston: Museum of Fine Arts, 1993), p. 254.

Page 15: Hayden Herrera, *A Biography of Frida Kahlo* (New York: Harper & Row, 1983), pp. 241–250.

Page 16: Frida Kahlo, *Frida by Frida* (Mexico: Editorial RM, 2006), p. 357.

Pete Hamill, *Diego Rivera* (New York: Harry N. Abrams, 1999), pp. 52–54.

Page 17: Hayden Herrera. *A Biography of Frida Kahlo* (New York: Harper & Row, 1983), pp. 204–210.

Page 18: Pete Hamill, *Diego Rivera* (New York: Harry N. Abrams, 1999), pp. 167–168, 190.

Page 19: Frida Kahlo, *Frida by Frida* (Mexico: Editorial RM, 2006), p. 324.

Page 20: Hayden Herrera, *A Biography of Frida Kahlo* (New York: Harper & Row, 1983), p. 217.

Page 22: *Ibid.*, pp. 80, 85.

Page 23: Elizabeth Carpenter, ed. *Frida Kahlo* (Minneapolis: Walker Art Center, 2007), p. 43.

Page 25: Diego Rivera and Gladys March, *My Art, My Life: An Autobiography* (New York: Citadel, 1960), p. 188.

Page 26: Elizabeth Carpenter, ed., *Frida Kahlo* (Minneapolis: Walker Art Center, 2007), p. 237.

Page 27: Hayden Herrera. *A Biography of Frida Kahlo* (New York: Harper & Row, 1983), pp. 154–157.

Page 28: Frida Kahlo, *Frida by Frida* (Mexico: Editorial RM, 2006), p. 124.

Page 29: Elizabeth Carpenter, ed., *Frida Kahlo* (Minneapolis: Walker Art Center, 2007), p. 226.

Page 30: Salomon Grimberg, *I Will Never Forget You: Frida Kahlo and Nickolas Muray* (Munich: Schirmer/Mosel, 2004), pp. 14–39.

Page 31: Hayden Herrera, *A Biography of Frida Kahlo* (New York: Harper & Row, 1983), p. 80.

Page 32: Frida Kahlo, *The Diary of Frida Kahlo: An Intimate Self-portrait* (New York: Harry N. Abrams, 1995), p. 252.

Page 33: *Ibid.*, p. 274.

Page 34: Cynthia Newman Helms, *Diego Rivera* (New York: W. W. Norton & Co., 1986), pp. 268–273.

Page 35: Pete Hamill, *Diego Rivera* (New York: Harry N. Abrams, 1999), pp. 167–168, 178.

Page 36: Hayden Herrera, *Frida Kahlo: The Paintings* (New York: Harper Collins, 1991), p. 124.

Page 37: Denise and Magdalena Rosenzweig, eds., *Self Portrait in a Velvet Dress* (San Francisco: Chronicle, 2007), p. 108.

Page 38: Cynthia Newman Helms, *Diego Rivera* (New York: W. W. Norton & Co., 1986), pp. 302–304.

Page 39: *Ibid.*, pp. 305–307.

Ibid., pp. 269–273.

Page 42: Elizabeth Carpenter, ed., *Frida Kahlo* (Minneapolis: Walker Art Center, 2007), pp. 50–51.

Page 43: *Ibid.*, p. 37.

Page 44: *Ibid.*, p. 234.

Page 45: Martha Zamora, *Frida Kahlo: The Brush of Anguish* (San Francisco: Chronicle, 1990), p. 37.

Page 46: Isabel Alcantara and Sandra Egnolgg, *Frida Kahlo and Diego Rivera* (Munich: Prestel Verlag, 1999), p. 59.

Page 47: Adam Bernstein. "Frances Rich, 97; Sculpted Alternative to Hollywood." *The Washington Post,* Friday, October 26, 2007: B07. http://www.washingtonpost.com/wp-dyn/content/article/2007/10/25/AR2007102502626.html.

Page 48: Elizabeth Carpenter, ed., *Frida Kahlo* (Minneapolis: Walker Art Center, 2007), pp. 40–41.

Page 49: *Ibid.*, p. 250.

Page 50: Hayden Herrera, *Frida Kahlo: The Paintings* (New York: Harper Collins, 1991), p. 23.

Page 51: Elizabeth Carpenter, ed., *Frida Kahlo* (Minneapolis: Walker Art Center, 2007), p. 270.

Page 52: Frida Kahlo, *Frida by Frida* (Mexico: Editorial RM, 2006), p. 158.

Page 54: Elizabeth Carpenter, ed., *Frida Kahlo* (Minneapolis: Walker Art Center, 2007), p. 268.

Page 55: *Ibid.*, p. 231.

Ibid., p. 43.

Page 56: *Ibid.*, p. 247.

Ibid., p. 240.

Page 57: *Ibid.*, p. 266.

Page 59: Frida Kahlo, *Frida by Frida* (Mexico: Editorial RM, 2006), p. 245.

Page 96: Cynthia Newman Helms, *Diego Rivera* (New York: W. W. Norton & Co., 1986), p. 286.

Page 97: Elizabeth Carpenter, ed., *Frida Kahlo* (Minneapolis: Walker Art Center, 2007), p. 238.

Page 99: *Ibid.*, p. 229.

Page 100: Hayden Herrera, *A Biography of Frida Kahlo* (New York: Harper & Row, 1983), pp. 409–410.

Page 101: Denise and Magdalena Rosenzweig, eds., *Self Portrait in a Velvet Dress* (San Francisco: Chronicle, 2007), pp. 126–127.

Page 102: Bertram Wolfe, *The Fabulous Life of Diego Rivera* (Lanham, MD: Scarborough House, 1990), p. 145.

Page 104: Bettman Archive/Corbis: www.corbisimages.com.

Page 105: Diego Rivera and Gladys March, *My Art, My Life: An Autobiography* (New York: Citadel, 1960), p. 155.

Page 106: Martha Zamora, ed., *The Letters of Frida Kahlo: Cartas Aspasionadas* (San Francisco: Chronicle, 1995), p. 149.

Page 108: Elizabeth Carpenter, ed., *Frida Kahlo* (Minneapolis: Walker Art Center, 2007), p. 266.

Page 110: "Mexican Autobiography." *Time,* Monday, April 27, 1953. http://www.time.com/time/magazine/article/0,9171,818329,00.html.

Page 111: Elizabeth Carpenter, ed., *Frida Kahlo* (Minneapolis: Walker Art Center, 2007), p. 279.

Page 113: *Ibid.*, p. 244.

Page 116: Diego Rivera and Gladys March, *My Art, My Life: An Autobiography* (New York: Citadel, 1960), p. 131.

Page 118: Frida Kahlo, *Frida by Frida* (Mexico: Editorial RM, 2006), pp. 344–345.

Page 119: Hayden Herrera, *A Biography of Frida Kahlo* (New York: Harper & Row, 1983), p. 126.

Page 120: Elizabeth Carpenter, ed., *Frida Kahlo* (Minneapolis: Walker Art Center, 2007), p. 265.

Page 121: *Ibid.*, p. 287.

Page 122: Diego Rivera and Gladys March, *My Art, My Life: An Autobiography* (New York: Citadel, 1960), p. 180.

Page 123: Salomon Grimberg, *Frida Kahlo: Song of Herself* (London: Merrill, 2008), p. 47.

Page 125: Frida Kahlo, *The Diary of Frida Kahlo: An Intimate Self-portrait* (New York: Harry N. Abrams, 1995), p. 243.

Page 129: Elizabeth Carpenter, ed., *Frida Kahlo* (Minneapolis: Walker Art Center, 2007), p. 48.

Page 130: Hayden Herrera, *A Biography of Frida Kahlo* (New York: Harper & Row, 1983), p. 95.

Elizabeth Carpenter, ed., *Frida Kahlo* (Minneapolis: Walker Art Center, 2007), p. 277.

Page 131: Frida Kahlo, *The Diary Frida Kahlo: An Intimate Self-portrait* (New York: Harry N. Abrams, 1995), p. 234.

BIBLIOGRAPHY

Alcántara, Isabel, and Sandra Egnolff. *Frida Kahlo and Diego Rivera*. Munich: Prestel Verlag, 1999.

Arquin, Florence. *Diego Rivera: The Shaping of an Artist. 1889–1921.* University of Oklahoma Press, 1971.

Billeter, Erika, ed. *The World of Frida Kahlo*. Frankfurt: Schirn Kunsthalle; Boston: Museum of Fine Arts; 1993.

Carpenter, Elizabeth, ed., Hayden Herrera, and Victor Zamudio-Taylor. *Frida Kahlo*. Minneapolis: Walker Art Center, 2007.

Grimberg, Salomon. *Frida Kahlo: Song of Herself.* London: Merrill, 2008.

———. *I Will Never Forget You: Frida Kahlo and Nickolas Muray.* Munich: Schirmer/Mosel, 2004.

Hamill, Pete. *Diego Rivera*. New York: Harry N. Abrams, 1999.

Helms, Cynthia Newman, ed. *Diego Rivera*. New York: W. W. Norton & Co., 1986.

Herrera, Hayden. *Frida: A Biography of Frida Kahlo.* New York: Harper & Row, 1983.

———. *Frida Kahlo: The Paintings.* New York: Harper Collins, 1991.

Hooks, Margaret. *Frida Kahlo: Portraits of an Icon.* Madrid, New York: Turner Publicaciónes/Throckmorton Fine Art, 2002.

———. *Tina Modotti: Photographer and Revolutionary.* London: Pandora, 1993.

Instituto Nacional de Bellas Artes. *Frida Kahlo 1907.* Mexico: Editorial RM, 2008.

Kahlo, Frida. *The Diary of Frida Kahlo: An Intimate Self-portrait.* New York: Harry N. Abrams; 1995.

Kahlo, Isolda P. *Frida Íntima.* Bogotá: Ediciónes Dipon; Buenos Aires: Ediciónes Gato Azul, 2004.

Kettenmann, Andrea. *Rivera.* Taschen, 2000.

Landucci Editores. *Frida Kahlo.* New York: Bulfinch Press, 2001.

Poniatowska, Elena. *Frida Kahlo: The Camera Seduced.* London: Chatto & Windus, 1992.

Rivera, Diego, and Gladys March. *My Art, My Life: An Autobiography.* New York: Citadel Press, 1960.

Rosenzweig, Denise, and Magdalena Rosenzweig, eds. *Self Portrait in a Velvet Dress.* San Francisco: Chronicle, 2007.

Tibol, Raquel, ed. *Frida by Frida.* Mexico: Editorial RM, 2006.

Weiler, Marie, ed. *I Painted My Own Reality* [notecards]. San Francisco: Chronicle, 1995.

Wolfe, Bertram D. *The Fabulous Life of Diego Rivera.* Lanhan, MD: Scarborough House, 1990.

Zamora, Martha. *Frida Kahlo: The Brush of Anguish.* San Francisco: Chronicle, 1990.

———. *The Letters of Frida Kahlo: Cartas Apasionadas.* San Francisco: Chronicle, 1995.

Web sites: www.luciennebloch.com.

INDEX

ACKNOWLEDGMENTS

I am extremely grateful to Anne Horton and the Mary-Anne Martin gallery for making me aware of this incredible collection.

I am appreciative of Suzanne Slesin and Jane Creech for being so excited about seeing the unique work of the collection and running with the project. And also for bringing on such an incredible art director, Sam Shahid.

Special thanks to Alison Uljee for working with me in preparing the material for publication.
—Vicente Wolf

Pointed Leaf Press would like to thank Vicente Wolf for entrusting us with his collection of Frida Kahlo's personal photographs. We are grateful to art director extraordinaire Sam Shahid and his talented and tireless associate Betty Eng for the enthusiasm, creativity, and care with which they approached the project; to Kathryn Millan, who spent months researching Frida and her world in order to connect the photographs with some of the actual events of the time, as well as culling entries from Frida's own writings and the numerous books written by the artist's esteemed biographers; to Elizabeth Gall, our indefatigable copy editor; to Regan Toews, who researched, organized, and created a workable template for the photographs and their accompanying captions; to Peter Riesett and his assistant, Michael Moreno, for the sensitive and expert manner in which they handled and photographed the original documents; and to Dennis Murphy, who helped us tie up all the loose ends as our publication date approached.
—Suzanne Slesin and Jane Creech, January 2010, New York.

PUBLISHER/EDITORIAL DIRECTOR Suzanne Slesin MANAGING EDITOR Jane Creech RESEARCHER/WRITER Kathryn Millan COPY EDITOR Elizabeth Gall
PRODUCTION ASSOCIATE Regan Toews PRODUCTION ASSISTANT Dennis Murphy

Design by Sam Shahid

Library of Congress number: 2009943169 ISBN: 978-0-9823585-3-5 © 2010 Vicente Wolf

First edition
10 9 8 7 6 5 4 3 2 1

The photographs from the Vicente Wolf Collection shown here were photographed by Peter Riesett. Every effort was made to locate copyright holders; corrections will be made in future printings; photo by Fritz Bach 18; photo by Lucienne Bloch, courtesy of Old Stage Studios, www.LucienneBloch.com 18, 49, 55, 131; photo by Lola Álvarez Bravo, Collection Center for Creative Photography, University of Arizona © 1995 The University of Arizona Foundation 100, 132; photo by Manuel Álvarez Bravo © Colette Urbajtel 15, 55; photo by Carlos Dávila 43; photo by Gisèle Freund 32; photo by Hector Garcia 19, 110, 111; photo by R. Garcia 29; photo by Guillermo Kahlo © Guillermo Kahlo Estate 27, 48, 50; photo by Julien Levy 42; photo by Tina Modotti 22; photo by Nickolas Muray © Nickolas Muray photo Archives 10, 23, 30, 51, 127; photo attributed to Juan O'Gorman 33; photo by Sylvia Salmi 19; photo by Carl Van Vechten, Van Vechten Trust 7, 37; photo by Guillermo Zamora 121.